TOUHY vs. CAPONE

TOUHY vs. CAPONE

The Chicago Outfit's Biggest Frame Job

Don Herion

THE
History
PRESS

Published by The History Press
Charleston, SC
www.historypress.net

Copyright © 2017 by Donald H. Herion
All rights reserved

First published 2017

Manufactured in the United States

ISBN 9781625858931

Library of Congress Control Number: 2017934941

CONTENTS

CONTENTS

1

MY INTRODUCTION TO ROGER TOUHY

It was December 16, 1959, when my partner, Bob Peters, and I reported for work on the four-to-twelve watch. I had joined the Chicago Police Department on February 1, 1955. Bob became a cop about the same time, and we were partners on squad car no. 121. As usual, the weather was miserable—about eight degrees, damp, windy and very nasty. We both smoked, so we had opened our windows slightly to keep from getting asphyxiated.

At night, sound traveled more clearly because of less traffic and the open windows. Traveling west on Washington Boulevard near Pine and Lotus Avenues—at the west end of our district—we heard what sounded like a truck backfiring. I asked Bob if he thought what I thought: those were not backfires but gunshots, and the hunting season was over. We headed toward the area where we heard the shots. Just then, the squad operator gave out a message of shots fired at 125 North Lotus Avenue and instructed responders to check out two men running from the scene with what appeared to be rifles.

When we arrived at the scene, which was a two-story brick building, we saw two men lying on the front porch, with blood everywhere. Both men had been shot in their lower extremities. This was my introduction to Roger Touhy and his bodyguard Walter Miller, a retired Chicago cop.

When Touhy told me his name, I remembered reading about him in the newspapers and hearing stories about him on the radio when I was a teenager. I told him and Miller that we had called for an ambulance and

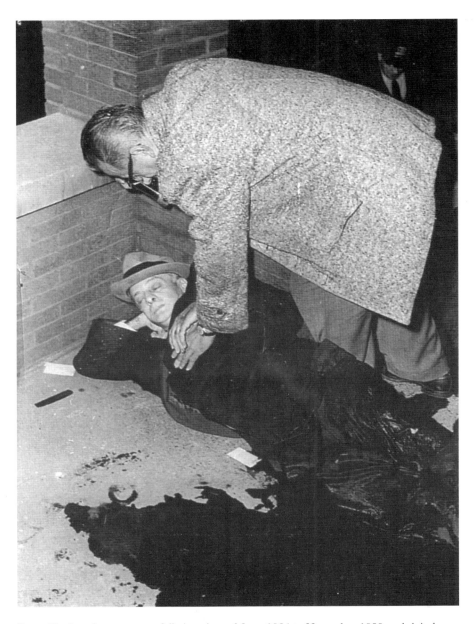

Roger Touhy, who was wrongfully imprisoned from 1934 to November 1959 and slain less than a month later. *Courtesy of the* Chicago Daily News.

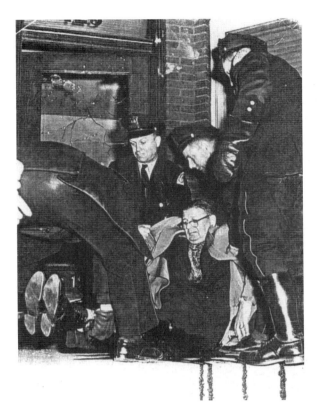

Left: W. Miller, bodyguard for Touhy, also shot. *Courtesy of the CPD.*

Below: "Touhy Slain in Ambush!" *Author's collection; courtesy of the CPD.*

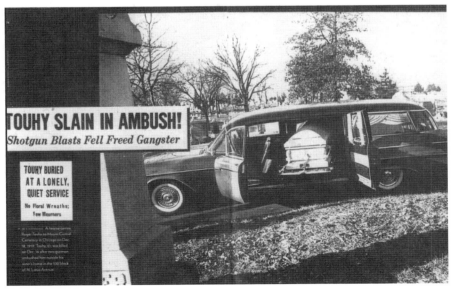

to hang in there. All he kept saying was, "Those fucking Dagoes, they never forget."

I asked Touhy what had happened. He said that when he and his bodyguard walked up the front steps and were about to enter his sister's apartment, they were ambushed by two guys with shotguns who came out of nowhere. He said that they were both knocked down by the blast.

Miller said he did fire a few shots at them, and he thought he may have hit one of them in the leg. Touhy was transported to St Anne's Hospital and arrived at the emergency room at 10:35 p.m. Walter Miller was taken to Loretta Hospital, and he survived. A shock trauma team headed by Dr. Vitullo attempted to apply a tourniquet to Touhy's leg to stop the massive loss of blood. The doctor worked frantically to save Touhy, but there had been too much blood loss already. A Catholic priest was brought in, and Touhy was given the last rites of the Catholic Church. Roger Touhy expired at 11:25 p.m.

My curiosity concerning Roger Touhy got the best of me, so I started checking on what the hell he did to have the Outfit kill him. Through numerous investigations and interrogations of mobsters I busted in my career of forty-six years of fighting the Outfit, I developed reliable informants who told me that the two hit men who shot and killed Roger Touhy were Milwaukee Phil Alderisio and Obie Frabotta. They killed him because Touhy was a potential threat to their operations.

2
ROGER TOUHY

The Beginning

Roger Touhy was born in Chicago in 1898 to Irish immigrant parents. His father, James A. Touhy, and his wife, Mary, were the parents of six sons and two daughters. James A. Touhy was a policeman on Chicago's Near West Side. When Roger was a small child, his mother died in a house fire. Roger Touhy grew up to be five feet, six inches tall, had curly hair and a hawk-like nose and was highly intelligent.

James Touhy could not properly raise his sons by himself, and five of them eventually turned to crime. James Touhy Jr. was shot and killed by a policeman during an attempted robbery in 1917. John Touhy was killed ten years later by gunmen from gangster Al Capone's Chicago Outfit. Joseph Touhy was shot dead by Capone gunmen in 1929.

Tommy "The Terrible" Touhy became a major organized crime figure in Chicago and was named "Public Enemy Number One" in 1934. Only Edward Touhy managed to stay out of trouble, by becoming a bartender.

Roger Touhy, the youngest of James Touhy's sons, tried to remain on the right side of the law. He dropped out of school after the eighth grade, not unusual at the time, and worked at various jobs, including as a telegrapher, an oil field worker and a union organizer. He served in the U.S. Navy during World War I and was discharged at the war's end. When he was a teenager, he got a job with Western Union, which gave him a chance to learn Morse code; the job paid twelve dollars a week.

He met his wife, Clara, at Western Union when she was sixteen years old and eventually married her in 1922. Touhy had learned a great deal

about unions and how they worked within Western Union. Every employer fought the unions then, and because he gave honest answers to a superintendent of the company and expressed his feelings about unions, he was fired.

He then moved west, where he was employed as a telegrapher with a railroad in Denver, and then migrated to Oklahoma to work as an oil field engineer for a short period of time. In an effort to get back to work, he heard that a New York geologist, Dick Raymond, needed a helper. Touhy got the job and traveled with Raymond all over southwest Oklahoma—this turned out to be very profitable for him. He invested in oil leases and sold them for a total of $25,000.

Being a city guy at heart, he returned to Chicago and married

Roger Touhy, bootlegger and enemy of Al Capone. *Courtesy of the CPD.*

Clara; they moved into an apartment in Oak Park, Illinois. His next move was to buy a taxicab, which he drove nights. After a few months, he opened his own garage and auto sales place with a capacity for ten cars. Business was very good, and he sold it and bought a bigger place on North Avenue. Up to this point, I couldn't find evidence of Touhy ever having been arrested or being in trouble with the law, as most alleged mobsters usually are.

Touhy and his wife moved from Oak Park to another suburb in Des Plaines, Illinois, where he bought a six-room bungalow and later had a swimming pool put in the backyard. The newspapers later called this house a "mansion" or a "gang fortress." Touhy claimed that the only gang that he ever had around his house was a guard with a shotgun after the Capone mob tried to kidnap his two sons.

Touhy got in the beer business by chance: he bought eight trucks at a bargain price, sold six of them and wound up with two trucks sitting around in his garage doing nothing. He knew most of the bootleggers and bar owners in his area, so why not get involved. He called on a few of the bar

owners and then made a deal with two young fellas who would work hard to make a dollar. Touhy made a deal to buy beer from two breweries that turned out legal ½ to 1 percent Prohibition beer and sneaked the good beer out the back door. His trucks hauled the beer, the drivers made a profit of twenty dollars a barrel and they paid him a percentage on the purchase price of the trucks. Touhy said that some police generally expected a payoff of five dollars a barrel for beer being run into any given district. He also said that he and his drivers didn't pay it because his operation was too small for the law to bother much with them. One of Touhy's trucks, carrying three barrels of beer, was stopped by a police sergeant named Dan "Tubbo" Gilbert. Gilbert arrested the driver and took the beer to the station. It so happened that Touhy claimed he had met Gilbert when he was a labor organizer for the syndicate in a score of unions, and Gilbert did not like Touhy.

The three barrels of beer turned out to be legal stuff, ½ to 1 percent, and Gilbert had to release the beer, the driver and the truck, which really pissed Gilbert off. Touhy said that he circulated that story around Chicago, which was quite embarrassing for Gilbert. It took Gilbert a long time to get revenge against Touhy, but he finally did: ninety-nine years in prison. Touhy really got his start big time in the bootleg business when a friend of his, Matt Kolb, made him an offer he couldn't refuse. Kolb was a roly-poly guy—five foot, three inches and about 250 pounds—and had at one time been tied in with the Capone mob, but the violence had scared him away from them.

Kolb was known for his political connections involving gambling and bootlegging in the northwest section of Cook County. Touhy had been taking in about $50,000 a year from his automobile business, decided to be Kolb's partner and gave him $10,000. They were off and running.

Touhy found out that Kolb's beer tasted awful and was inconsistent in flavor. So the first thing Touhy did was to consult with a chemist and ask him about how he could make good beer. He was told to find good pure water, which was the big thing in making good beer. After testing the water all over northern Illinois, it was decided that an artesian well near Roselle, Illinois, was the best. A wort plant was built there, and Touhy put his brother Eddie in charge of it.

Wort is a liquid portion of mashed or malted grain produced during the fermenting process before hops and yeast are added. Touhy wanted to make the best beer in America, and the saloonkeepers would come begging to buy it. Touhy used nothing but the best ingredients and did everything he could to make the best-tasting beer, which proved to be a success. Of course, this was an illegal operation and in violation of the federal laws,

but everybody—from bankers to clergymen, mayors, U.S. senators and the corner grocery clerk—drank his beer and enjoyed it.

Touhy invested $50,000 in this business before he sold his first stein of beer. He even had union workers build barrels for him at a place in Schiller Park, Illinois, because other barrels would spring leaks and release carbonation at times and could cause a lot of trouble. Touhy and Kolb had ten fermenting plants, each one a small brewery in itself. It was too much of a gamble to have the complete works in one place, which federal Prohibition agents might raid and chop up.

Touhy's operation was well run, and his product was a lot better than beer made in bathtubs in some basement. Touhy was selling one thousand barrels a week at $55.00 a barrel to saloon owners. It cost $4.50 a barrel to produce beer using the finest ingredients; water was cheap, and there was a lot of it in beer.

They sold beer to about two hundred locations outside the Chicago area to the west and northwest of Chicago. Their business was scattered all over the suburbs, and nobody realized that Kolb and Touhy were grossing about $1 million a year from beer alone. Federal agents stuck pretty much to the big cities like Chicago, so Touhy didn't catch too much heat from law enforcement. It was still the late '20s when Touhy and Matt Kolb got involved with slot machines. They were against the law to possess, but they stood in the open in practically every roadhouse, drug house, gas station or saloon in Cook County. They had 225 of them in choice locations and were clearing about $9,000 a week from the slots.

3

AL CAPONE TAKES ON BUGS MORAN

Al Capone was one of the most infamous gangsters of the twentieth century, a gangster of international prominence whose name evokes the worst of gangland mayhem. He was certainly not without intelligence, but in essence he was a sadistic savage who used brute strength to achieve what he wanted. He ran the Chicago mob and was responsible for an untold number of murders, including the famous St. Valentine's Day Massacre on February 14, 1929, when seven of Bugs Moran's men were machine-gunned to death. Bugs Moran, who ran the North Side Gang, was in competition with Capone in the bootlegging business during Prohibition. They hated each other. Everyone thought that Moran was Irish, but he was actually born in Minnesota to Polish parents and named Abelard Cumin. He came to Chicago at the age of nineteen.

Capone has been credited with perhaps one thousand murders. Because he never paid any income tax, the IRS nailed him, and he was sentenced to eleven years in jail. Most of Capone's time was spent in Alcatraz, where he was eventually judged insane, and he was released in 1939. It seems that one of his whores gave him syphilis, and the disease destroyed him. Capone spent the rest of his years in Miami Beach, Florida, in a mansion he bought for $40,000 in 1928, dying of a brain hemorrhage on January 25, 1947, at the age of forty-eight.

Bugs Moran got out of the bootlegging racket after the St. Valentine's Day Massacre, having heeded Capone's warning. On February 25, 1957, at sixty-six years of age, Moran died of lung cancer in Leavenworth penitentiary, where he was serving a sentence for burglary and robbery.

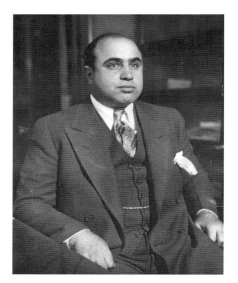 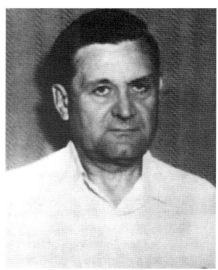

Left: Al Capone, mob boss and killer. *Public domain.*

Right: George "Bugs" Moran. *Courtesy of the FBI.*

Capone and Moran rose to power in the 1920s because Prohibition ruled America. Prohibition produced a lawless period in this country, including its citizenry. Al Capone became the era's biggest bootlegger and mob boss of the union extortion racket.

4

AL CAPONE

The Beginning

In 1899, Alphonse "Scarface" Capone was born in Brooklyn, New York, the fourth of nine children of immigrant parents from Naples, Italy. He attended school until the sixth grade, when he proceeded to beat up his teacher and was in turn beaten by the principal. The young Capone quit school for good. After that, he learned street smarts and joined a tough outfit of teenagers called the James Street Gang. This gang was run by an older criminal, Johnny Torrio, and was a youthful subsidiary of the notorious Five Points Gang, to which Capone later graduated. One of his closest friends in the gang was to become a major crime figure: Lucky Luciano. They remained close friends for the rest of their lives.

When Capone was still in his teens, he was hired by Johnny Torrio and his partner, Frankie Yale, as a bouncer in a saloon brothel they ran in Brooklyn. This was where Capone picked up his name of "Scarface Al," after his left cheek was slashed in a fight over a girl with another hoodlum named Frank Galluccio. Later, Capone would tell friends and reporters that he was wounded in France in the Great War, but he was never in the service.

Capone got in trouble in 1919, when the police were trying to pin a couple of murders on him. Johnny Torrio, who had been summoned to Chicago to help his uncle Big Jim Colosimo operate his whoremaster business—the biggest in the city—instructed Capone to come to Chicago to help him run his uncle's empire. By the time Capone arrived in Chicago, Torrio was having a major dispute with Big Jim. Torrio wanted Colosimo to shift his organization's main thrust to bootlegging with the coming of Prohibition.

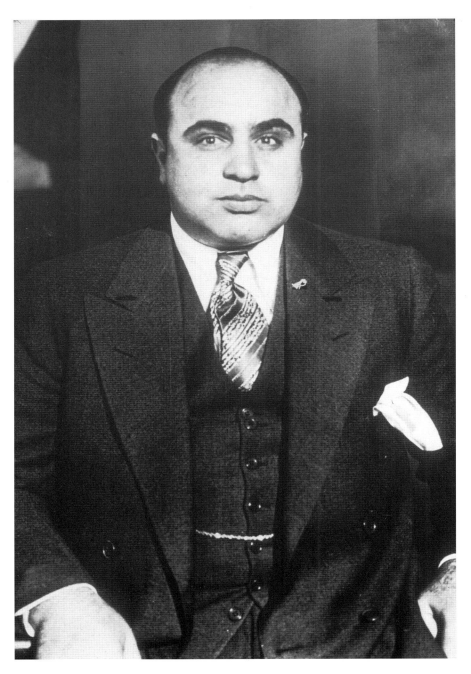

Al Capone, mob boss and the most infamous gangster in the world. *Courtesy of the FBI.*

Big Jim wasn't interested, having become rich in the whoring trade, and saw no reason to expand. He ordered Torrio to not get involved in bootlegging.

Torrio now was aware that Big Jim had to be eradicated so that he could use his organization for his bootlegging plans. Together, Torrio and Capone planned Colosimo's murder, and a request for the job was sent to New York for talent to carry out the job. In the meantime, Torrio and Capone planned out their alibis. Colosimo's assassination took place in the vestibule of his restaurant on May 11, 1920, by New York killer Frankie Yale.

The Torrio-Capone duo was soon on the move, taking over mobs that bowed to threats. Their most impressive killing was that of Dion O'Banion, the head of the largely Irish North Side Gang. They again used the talents of Frankie Yale, Albert Anselmi and John Scalise, who were called the murder team. O'Banion's death failed to rout the North Siders, who instead waged war off and on for several years. Torrio was ambushed and shot and almost died. When he got out of the hospital in February 1925, Torrio told Capone after considerable thought, "Al, it's all yours." Torrio took the $30 million he had salted away and retired to Brooklyn, where he acted as an adviser to the leaders of organized crime and the national crime syndicate that would emerge in the 1930s.

This came as a complete surprise and shock to Capone, who had just reached the age of twenty-six. He had always used his muscle, which was his strong suit. Now, instead, he was in a position that called for brain power. He was now a major business executive heading a workforce of one thousand persons, with a payroll of over $300,000 a week.

He had to demonstrate that he could work with other ethnics, including Irish, Poles, Jews and blacks. Capone excelled in this, appreciating any man provided he was a hustler, crook or a killer. There was never an intimation that he discriminated against any of them because of their religion, race or national origin. Capone might have been the underworld's first equal opportunity employer. Of course, he killed a number of ethnics if they didn't obey his orders, but he did the same to many of Chicago's Mafiosi, including the Gennas and Aiellos, for the same reason.

Capone did a thorough job of purging Chicago of Mafia Mustache Petes long before Lucky Luciano succeeded in doing so in New York. Although he was a murderer and continued to order wholesale butchery as the head of the Outfit, Capone nevertheless maintained a public image, mixing well with political, business and even social figures. He attempted to give the impression that his business was a "public utility" by limiting his mob's activities mainly to rackets that enjoyed strong public support, such as booze,

Left: Al Capone's armor-plated car. *Author's collection.*

Below: The Lexington Hotel, Capone's headquarters. *Author's collection; courtesy of the CPD.*

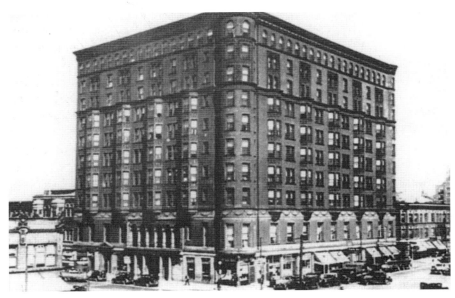

gambling and prostitution. If you give people what they want, inevitably, you gain a certain respectability and popularity. When Al Capone went to the ballpark, he got cheered. After 1929, Herbert Hoover was not. Of course, Capone surrounded himself with gangsters he could trust, and his trust was, in turn, returned to him by his men. As long as a gangster didn't try to double-cross him, Capone backed him to the limit. Capone was constantly under an assassination threat. He was shot at numerous times and once almost had his soup poisoned.

In 1926, the O'Banions sent an entire machine-gun motorcade past the Hawthorne Inn, Capone's Cicero headquarters, and poured in one thousand rounds, but Capone escaped injury when his bodyguard shoved him to the floor of the dining room and fell on top of him. One by one, Capone did eliminate his enemies, especially the North Siders. His most famous personal killings involved treachery within his own mob. Two of Capone's trusted most lethal killers, John Scalise and Albert Atkins, were showing signs of cooperating with other Capone enemies to kill him. Capone invited them to a banquet in their honor and, at the climax of the evening, produced a gift-wrapped Indian club—with which he bashed their brains out.

This occurred in 1929, a fatal year for Capone. Just shortly before the head-bashing incident, he committed a giant blunder in ordering the St. Valentine's Day Massacre in an effort to kill Bugs Moran, the last major leader of the old O'Banion gang. Seven men were lined up against a garage wall by hit men dressed as police officers. Fortunately for Moran, he was not present at the time. The victims thought they were being subjected to a routine arrest and offered no resistance. After this massacre, the public attitude started to change about the savage bootleg wars. Washington applied heat on Capone and the Chicago Outfit. The Feds couldn't convict him of murder, but they eventually got him for income tax evasion and sentenced him to eleven years in federal prison in Atlanta.

In 1934, he was transferred to Alcatraz, "The Rock," where his health began to deteriorate. He was suffering from the ravages of untreated syphilis contracted in his early whorehouse days. Released in 1939, he was a pathetic case. His family took him to his mansion in Florida, where he was to live out the next eight years, alternating between lucidity and mental inertia. There was no way he could be involved in any mob business or activity. He died on January 25, 1947.

5

JOHN "JAKE THE BARBER" FACTOR

John Factor was an international speculator, gambler and investment tipster, known to his numerous detractors as "Jake the Barber," the outcast brother of cosmetics czar Max Factor. Jake was an illegal immigrant in the United States, having fled England to avoid a long jail term for engineering one of the biggest stock frauds in the history of the British Empire.

Jake was having his troubles in 1933, because for more than two years, the British government had been trying to extradite him to England, where his majesty's counsel claimed Factor had swindled King George V's subjects of more than $7 million. In a desperate attempt to save himself from extradition, Factor had associated himself with crime syndicate boss Al Capone. Factor was aware that Capone disliked Roger Touhy and wanted to take over his bootlegging operation in the suburbs. Factor knew Capone would cooperate with him in a kidnap plot by blaming Touhy. Factor, being an exceptionally smart and practical man, knew that he was going to lose his case before the court and be deported, no matter how many shrewd lawyers he could buy with his illegal wealth.

If he, Jake, were kidnapped and then returned safely and his kidnappers were captured, then the ensuing trial would delay his hearings long enough for the statute of limitations against him to run out. It wasn't a sure thing, but unless drastic measures were taken, his deportation to a jail cell in England was guaranteed.

Factor probably brought the idea to Murray Humpreys first, who brought the idea to his boss, Frank Nitti, who liked it. Humpreys, Nitti and probably

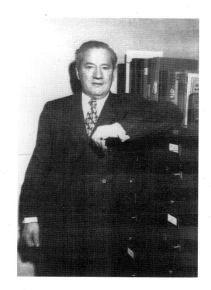

John "Jake the Barber" Factor, con man. *Courtesy of the FBI and Scotland Yard.*

Paul Ricca agreed that this was a good way to get rid of Roger Touhy. After all, the mob wasn't having any luck shooting Touhy or blowing him up, which they had tried several times in the past year.

Murray Humpreys learned that two of Touhy's former employees, Buck Henrichsen and George Wilke, volunteered to be witnesses against Touhy. Jake the Barber lost his battle with the U.S. Supreme Court and was ordered to be extradited back to England.

Prosecuting state's attorney Thomas Courtney met with Special Assistant U.S. Attorney General Keenan to get permission to meet with President Roosevelt. Upon getting Keenan's approval, Courtney immediately left for Washington, D.C. He had a conference with President Roosevelt, telling him that Jake was needed in America to convict a gang of the nation's most vicious kidnappers, including Roger Touhy.

FDR had no way of hearing Touhy's side of the story, which may have made a difference. FDR telephoned Secretary of State Cordell Hull and asked him to tell the British Embassy that Factor's removal to England was being held up indefinitely. Factor had just pulled off the biggest con job of his life. He had fooled the president of the United States. When Jake received the news, he threw a party, complete with champagne.

6

TOUHY MEETS CAPONE

Touhy related how he had met Al Capone about half a dozen times, mostly in Florida on fishing trips. Reliable informants stated that Touhy always refused to stay at Capone's mansion or use his yacht on Palm Island in Biscayne Bay, near Miami. "Capone wasn't my kind of guy. People around him or against him always seemed to meet a violent death. He surrounded himself with mobsters and killers." Roger Touhy almost never carried a gun—except on hunting and fishing trips—and had a rule that none of his employees could carry a gun.

Touhy had two business dealings with Capone in 1927. It seems that after agents raided two of Capone's Chicago breweries, he had trouble getting enough beer for his Chicago and Cicero speak-easies. Al's brother Ralph was in charge of beer for the syndicate, but Al himself called Touhy and asked Touhy to sell him 500 barrels. It just so happened that Touhy had a surplus at the time, so he agreed to sell Capone the beer at a discount price of $37.50 a barrel because of the large order. A few days later, Capone called Touhy back and asked for 300 more. Touhy said okay and informed Capone that Tuesday was the day that he collected from all his customers and paid his employees, so he expected to be paid then. The next Monday, Capone called Touhy, complaining that 50 of the barrels were leaking, so he would only pay for 750. Touhy laughed at him, because he knew that there couldn't have been any leaky barrels with the experts he used to build and package the beer. Touhy was a perfectionist and would always test the barrels before filling them with beer.

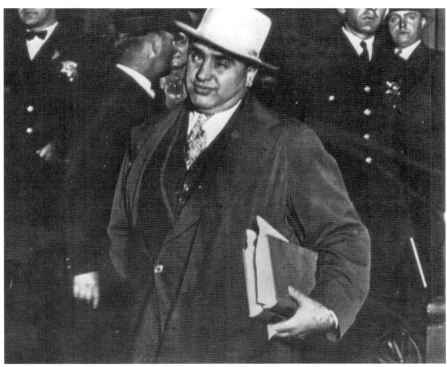

Above: Al Capone winking at the camera. *Courtesy of V. Inserra and the FBI.*

Left: Al Capone fishing on a yacht in Florida. *Courtesy of the FBI and CPD.*

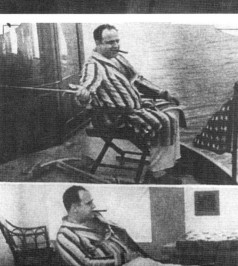

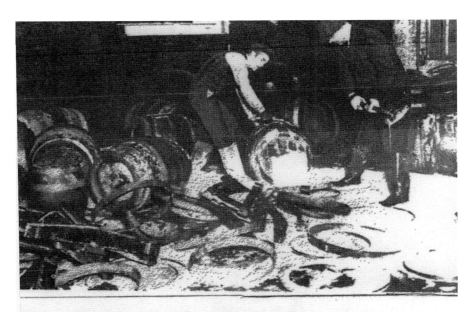

Prohibition agents are shown busting up one
of Al Capone's breweries, which didn't
make me feel a bit bad. After a lot of
Capone's breweries had been raided, he
bought beer from me—and tried to cheat
me on the price.

After one of Capone's breweries was raided, Touhy sold him beer. *Courtesy of the* Chicago
Herald Examiner.

Touhy informed Capone that he was aware that Capone was trying to chisel him out of fifty barrels and stated, "You owe me for eight hundred barrels, and I expect to get paid for eight hundred, Al."

Capone responded, "Well, the guys told me there were fifty leakers, I'll check into it." Capone knew what he owed Touhy and surprisingly paid up, $30,000 in cash.

Capone called Touhy a week later and asked to buy another five hundred barrels. Touhy told him that his regular customers were taking all of his supply so he had no beer to sell. After his last business transaction, he didn't want to deal with a snake like Capone.

7

CAPONE GANG INVADES TOUHY TERRITORY

U pon Al Capone being incarcerated in Alcatraz, he placed his top man in charge, Frank Nitti. Through Capone's orders, Nitti wanted to open up Touhy's territory with whorehouses and big-time gambling. He made an appointment with Touhy by phone, and a meeting was set up in a roadhouse—the Arch—owned by Touhy in Schiller Park, Illinois. He sent two torpedoes out to talk to Touhy.

Touhy was very resourceful. He set up the meeting place like a B movie. He had hung rifles, shotguns and pistols on the walls in the office. He had a friend on the county highway police force lend him two machine guns, which were part of a pending case in the suburbs. Touhy then stashed them in an open closet as window dressing for the two mobsters to see.

The roadhouse also had a gas station attached to it. Touhy made arrangements to have the attendant call him on the phone every time Touhy scratched his head, blew his nose or stood up from his chair. He told the attendant not to pay any attention to what he would say to him on the phone, as he was playing a joke on some friends. When the bad guys swaggered into the office, they became very meek after seeing the guns on the wall and the machine guns in the closet. Frankie Rio and Willie Heeney told Touhy what Capone wanted to do in the suburbs with whorehouses and gambling, even with punchboards to get the school kids money.

Touhy blew his nose, and the phone rang. He pretended to listen, began scowling and shouted into the phone that they were to send a few of the boys over there and take care of it. Rio continued on about Al's feelings

Louie Campagna (*right*) and Paul Ricca. *From* The Stolen Years, *by Roger Touhy*.

about opening up this virgin territory. Touhy laughed politely at this remark, but the mobsters didn't seem to think anything was very funny at this point. Touhy then coughed loudly, and on signal, a county cop came striding into the office from the bar. He grabbed the two tommy guns and told Touhy that Louie and he were going over to take care of those bastards one way or the other. Touhy said, "Do whatever it takes, Joe." Joe left with the tommy guns and returned them to the police arsenal from which they came. The phones kept ringing, and Touhy acted like Edward G. Robinson on the phone,

Machine Gun Jack McGurn, killer for Capone. *Courtesy of the* Chicago Daily News.

giving orders and directing his cohorts on how to commit violence. The two mobsters seemed to get a little pale and left the office before Touhy could think about killing them. Rio and Heeney said that they would go back and report to Nitti about their meeting.

Touhy had other guys like Louie Campagna, called "Little New York," and "Machine Gun" Jack McGurn—both killers—visit him. Campagna explained that Capone just wanted to expand a little out in the country, but he didn't want to compete with Touhy. As Campagna talked, Touhy kept scratching, blowing his nose, rising from his chair, answering the telephone and making like Little Caesar. Touhy's acting was a little silly, of course, but it impressed Campagna and McGurn, who just stood wide-eyed and nervous, looking and listening to Touhy directing his alleged gang to take care of business and show them no mercy. Touhy kept stalling Capone's messengers, telling them the local people were dead set against prostitution or casinos in their towns. Touhy knew that if the mob got a foot in the door, he would be put out of business.

Touhy went to the local chiefs of police and explained frankly that he wanted to stay in business, but added: "If the Capone mob gets into your towns, there will be no law left. The mobsters will be killing each other on your streets. You'll have a cathouse on every block." His argument was valid. Touhy had a good standing in the community, lived quietly, paid his taxes and was a leader in the Des Plaines Elk Club and other organizations. At one time, a group of businessmen even tried to get Touhy to run for mayor.

The word passed through the suburbs, and Touhy's advice was followed. As a starter, Capone's agents tried to install punchboards in the stores and shops. The effort was a complete failure. The merchants wouldn't buy the boards. Capone must have known that Touhy was behind this refusal of the merchants to cooperate. Touhy realized that he was making a powerful enemy, and he was going to pay for it, eventually.

8
TOUHY AND THE POLICE

The Chicago hoods kept pressuring him. Three of them—Rio, Capone's brother in law Frank Diamond and Sam Hunt, called "Golf Bag" because of the way he carried machine guns and shotguns—were at the Arch, "Touhy's place," one afternoon, the third time Touhy got a visit from the Chicago mob. Of course, the office was decorated with a variety of automatic weapons.

The ex-cops and brawny farmers on Touhy's payroll clomped in and out of the place. Rio asked Roger, "You've got a big organization, huh? A lot of good guys, I guess." Touhy shrugged casually. "There are two hundred guys out here from every penitentiary in the United States and a few from Canada. Which reminds me, Rio, we're having a big party tonight, most of my best guys will be here. Why don't you come out and bring some of the other boys?" Rio said that he would tell the boss about it and thanked Touhy for the invitation.

Touhy figured out what would probably happen, and it did. Six squads of Chicago police and deputy sheriffs from the other end of the county raided the Arch that night. Of course, the raid was a flop. Touhy figured right and closed the place for the night. The prop guns were gone, and there wasn't an ounce of anything alcoholic on the premises. Touhy felt great putting one over on Capone. Then things got serious. One day, Touhy got a call from Capone, who was very apologetic when he told him that Touhy's partner, Matt Kolb, had been kidnapped. Kolb was Touhy's partner in his illegal beer enterprise. Capone told Touhy it would cost

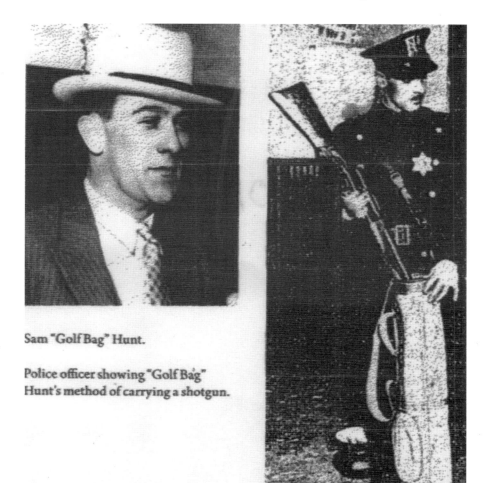

Sam "Golf Bag" Hunt.

Police officer showing "Golf Bag" Hunt's method of carrying a shotgun.

Sam "Golf Bag" Hunt, killer for Capone. *Courtesy of the FBI.*

$50,000 in fives, tens and twenties to get him loose. Capone, the generous character that he was, would be happy to act as intermediary. All Touhy had to do was bring the money to him, and he would make the payoff. Of course Touhy agreed to do it. What else?

Touhy went to the Proviso State bank in suburban Maywood, where he and Matt had about $140,000 in a joint account. He withdrew $50,000 and wrapped the money up in newspaper and drove downtown to Capone's

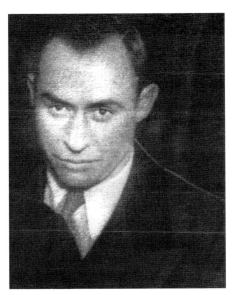

Frankie Rio, a Capone mobster, received an invite to a party. *Courtesy of the* Chicago Herald Examiner.

headquarters at the Metropole hotel. He took the elevator up to the fifth floor as directed by Capone. Five mobsters were sitting in the foyer, including Murray "The Camel" Humphreys. Capone was sitting behind a desk with six phones, acting like a big-shot executive. Touhy dropped the package on the desk. Al immediately opened it and told Touhy that he had nothing to do with the kidnapping, really liked Matt and was trying to help him. All Touhy said was "Where is he?" Capone instructed Touhy to drive around the block at Thirteenth and Michigan Avenue, and he would see him. Touhy did, and he saw Kolb on his second trip around the block. Kolb jumped into Touhy's car and apologized for being careless and getting kidnapped.

On November 18, 1931, Matt Kolb was shot to death in his club, Club Morton, on the corner of Dempster and Ferris Roads. Two men entered the club through the back door, and when Kolb attempted to shake hands, one of the men shot him six times. To make sure he was dead, the other man shot him in the head. No one was ever arrested for the murder. Kolb had been the political connection for Touhy, so, with him dead, Touhy now had a problem. However, Touhy's name never was mentioned prominently in the newspapers in connection with his death.

9
TOUHY AND THE UNIONS

In 1927, Touhy and his family spent many winters in Florida because the roadhouses would close up during cold weather and wouldn't return until spring. Touhy had spent considerable time fishing with a friend of his, Eddie McFadden, an old-timer with the teamster's union whom he'd met when he helped organize the telegraphers years ago.

One day, McFadden informed Touhy that the Capone mob was moving in on Touhy's labor union friends. A few union officials had been murdered, and the mob was out to grab the union treasuries, some of which ran into millions of dollars. This figured, of course. Everybody knew that Prohibition was going to end soon, so the syndicate had to tap a new source of money. In 1931, the federal government put Capone into prison for eleven years for income tax evasion. Word on the street was, Frank "The Enforcer" Nitti took his place, but in reality, the real boss was Paul "The Waiter" Ricca, and it was business as usual. When Prohibition was repealed, the syndicate's big income from bootlegging had ended. The Great Depression was settling down; banks closed, insurance companies busted out and brokers were jumping out of windows. Chicago gangsters had been in the business of providing thugs and scabs to break strikes for employers. In breaking a strike, Capone's mob would weaken the union involved and then put his own thieving men into the organization. Once a mobster got any authority, he took over the local, emptied the treasury and stole the monthly dues.

Touhy's friends from the past, who were still in the union, contacted him and explained how the mob was pressuring them. Several of them were

kidnapped or murdered or their homes bombed. They wanted to move out of Chicago and relocate in the suburbs where Touhy lived because it was safer for their families. Touhy told them that would be a good idea. Patrick Burrell, a Teamster Union International vice president, moved to Park Ridge, and some other union bosses followed him. The union officials always brought their armed bodyguards with them. Things got a little lively around the quiet suburban saloons for a while, but when Touhy sent word to McFadden that the bodyguards were asking for trouble with local law enforcement, McFadden resolved the issue to avoid problems.

In 1929, the syndicate had offered to cut Touhy and his brother Tommy in on a multimillion-dollar union racket. A Capone pimp, Marcus "Studdy" Looney, who was now a labor muscle, came out to Tommy Touhy's house in Oak Park, Illinois. Tommy phoned Roger and asked him to join them. Tommy did get into a lot of trouble and did time for burglary and mail robbery. He was just out of the Indiana State Prison. The newspapers got to calling him "Terrible Tommy" Touhy. Looney could hardly read or write but was a whiz at arithmetic, particularly at subtracting—subtracting money from people. He brought a list of Chicago-area unions and amounts of money in their treasuries, which added up to about $10 million, with the top prize to be stolen the union of Chicago milk wagon drivers: a bankroll of about $250,000 a year in dues.

Other unions were also mentioned, like the painters, electricians and movie projection booth operators. The union heads would have to knuckle in to the syndicate or be murdered in the years that followed. After dangling the prospect of big money in front of the Touhy brothers, he said, "The boss says that you can each have a union; which ones do you want?" Tommy and Roger both decided that they wanted no part of the scheme. They were polite but firm. Looney was very upset, warned them to keep their mouths shut about the mob's plans and left. Tommy and Roger immediately began calling their friends in the labor movement to warn them.

The syndicate soon learned that Touhy had warned the unions about their scheme to get the unions' treasuries. It was another black mark against Touhy that the mob never forgot. Touhy began hearing rumbles that his family and he might get hit by a bomb in his house. Touhy hired two guards: Walter "Buck" Henrichsen, a former county highway cop, and Eddie Schwabauer. Both were good shots and even better in court. One of the guards was sitting in Touhy's backyard playhouse with a shotgun while the kids, Tommy and Roger, went swimming in the pool.

10
ATTEMPTED KIDNAPPING

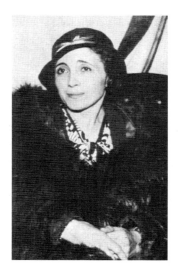

Clara Touhy, Roger's wife.
Courtesy of the FBI.

Clara and Roger drove the boys to parochial school, which was about two miles away. Touhy kept a man on duty outside the house all night. On one spring day, when Clara left to pick up the boys from school, Touhy was at home and received a phone call from one of the boys' teachers, who was screaming with hysteria. She said that two men in a car had tried to grab Tommy and Roger as they left school. When the boys saw Roger's wife, Clara, they ran and jumped in her car, and she drove away.

The teacher told Touhy that the two men were following Clara's car. Touhy loaded his deer rifle and drove as fast as he could to the school. Some teachers were on the school grounds crying; they waved frantically and pointed back the way he had just come. Cursing and raging, Touhy drove back, only this time more slowly. He thought for sure they had grabbed his family. Halfway home, he saw Clara's car pulling out of a driveway. She had stopped to buy eggs and milk from a farmer, which had probably saved them all. Clara hadn't noticed anything, but the teachers said that two men had jumped out of their car when the

boys came out of school. They ducked back when Tommy and Roger ran toward Clara's car parked at the curb.

She got away because the men had to make a U-turn to follow her. Roger increased the guards around the house and on the kids. He assigned Henrichsen, the former county cop, to watch the school to make sure the boys didn't get grabbed during recess or lunchtime. Things were quiet around Des Plaines and the other suburbs after that—but not in Chicago.

THE FRAMING OF TOUHY BEGINS

Paddy Burrell and his bodyguard Willie Marks went to Wisconsin on a vacation. Capone-style gunmen murdered them both when they were knee-deep in water, fishing. Bill Rooney, of the sheet metal workers, was also murdered by Capone's men at his home. Jake Lingle, a *Chicago Tribune* reporter, was murdered in Chicago when he was going to the racetrack. These deaths really caused the biggest stink about killings in Chicago, except for the St. Valentine's Day Massacre.

Roger Touhy admits that he never was considered a candidate for sainthood and did a lot of things in his life that he shouldn't have done, but he never kidnapped anybody. He never killed anybody, robbed or stole and never associated with killers. He admitted that he accepted them around the community as unavoidable evils in connection with his union friends, who needed them as bodyguards in their fight against the Chicago syndicate.

In the election of 1932, Franklin Roosevelt won in a landslide. Touhy was a Republican, mainly because the Cook County officials, as well as the suburban and township people with whom he dealt, were Republicans. The massacre of the GOP and the Democrats' victory meant for sure that beer and booze were going to be legalized. That would make Touhy legal. One of the Democrats who coasted into office on the Roosevelt landslide was Thomas A. Courtney as state's attorney for Cook Country, which was one of the most powerful prosecuting offices in America.

Courtney was one of the men who would help put Touhy in prison for ninety-nine years for a kidnapping that never happened. Courtney was

Prosecutor Crowley and his cohorts plotted against Touhy. *Courtesy of the FBI.*

without practical experience in criminal law, and he never prosecuted a case during the twelve years that he was state's attorney.

Courtney needed help from someone in law enforcement, so he appointed Captain Daniel "Tubbo" Gilbert, who had joined the Chicago Police Department in 1917. Being politically connected, he rose from patrolman to sergeant to lieutenant to captain in a few short years. He was assigned to the State Attorney's Office as chief investigator, where he remained for eighteen years. He was known as "the world's richest cop."

The fact remains that Gilbert was a mob flunky. In May 1939, he was seen over a three-day weekend at the Arlington Hotel in Hot Springs, Arkansas, at the bar and playing golf with Frank "The Enforcer" Nitti, Chicago mob boss. Gilbert was playing with gold-plated golf clubs that Nitti had given him as a present. During his time as chief investigator he never came up with evidence to send one Capone mobster—not one!—to jail for as much as one day. But sure, he put Touhy in the penitentiary and tried his best to make it the electric chair because Touhy was an enemy of the syndicate.

The mob tried to get rid of Touhy but failed. In an elaborate plan, the mob, along with Jake "The Barber" Factor, decided to fake Factor's kidnapping and blame Roger Touhy for it. Not only would they get rid of Touhy, but also Jake Factor would be able to stall his return to England,

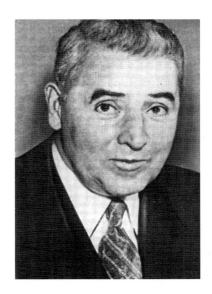

Daniel "Tubbo" Gilbert, richest cop in the world and perjurer. *Courtesy of V. Inserra and the FBI.*

where he had been found guilty of stock fraud, land fraud and mail fraud. After a gold mine stock swindle in Canada and another in Rhodesia, Factor was rich enough to live in a fourteen-room apartment on Chicago's Gold Coast and employ a chauffeur.

In 1923, Factor convinced New York's master criminal Arnold Rothstein to put up an initial cash investment of $50,000 that Factor needed to pull off the largest stock swindle in European history. Rothstein was a notorious gambler. He was suspected of being involved in fixing the 1919 World Series with the Chicago White Sox. He was a sharp gambler and played in many poker games. The night he was shot in a New York hotel, it is believed that he had lost $320,000 in a card game and refused to pay because he claimed the game was fixed. The police took him to a hospital and asked him who had shot him. Reportedly, he put two fingers to his lips and died without saying.

Rothstein was forty-six years old. Jack "Legs" Diamond, a friend of Rothstein, was a bootlegger, thief and killer, and he was aware of Rothstein's dealing with Factor and sent word to Factor that he was taking over all of Rothstein's rackets—including the Factor relationship—and wanted his share of the stock swindles. Factor never responded, probably assuming that once Rothstein, his original financier, was dead, the proceeds from the swindle were his and his alone.

Diamond disagreed and took a luxury liner to England to find the Barber, but Factor avoided him by simply returning to the United States and hiding out in Chicago, probably cutting in Chicago gangster Murray "The Camel" Humphreys for a percentage of his take. Factor knew that a killer like Diamond didn't give up easily, especially when millions were involved. Never a violent man, Jake was smart enough to partner up with those who had no aversion to violence. Legs Diamond gave up chasing Jake to attend his own trial in New York State for the attempted murder of a competitor in the bootlegging business, for which the jury returned a not guilty verdict.

The night after the decision, Diamond went out with friends and got drunk. He returned to his room in a boardinghouse in the early morning hours and fell into bed in a drunken stupor. A half hour later, two men entered Diamond's room and fired three .38-caliber bullets into his head, killing him. It was suspected that Murray Humphreys either engineered the murder or did it himself on behalf of his new best friend and business partner, Jake Factor. These suspicions were never proven, nor was there an investigation into the murder. No one really cared about Diamond being dead; that's all that really mattered. With Diamond out of the way, Factor came out of hiding, and when he did, he was arrested in Chicago on behalf of the British government for receiving property knowing it to be fraudulently obtained, but the Barber was released on a $50,000 bond.

12

JAKE'S EXTRADITION

On December 28, 1931, the U.S. Commissioner in Chicago ruled that Factor should be extradited to England, where he had already been tried and convicted in absentia and sentenced to eight years of hard labor. Factor's lawyers appealed on the grounds that each of his victims had received a small plot of land in South Africa—or at least the deed to one—and therefore no one was swindled. A federal judge agreed with Factor and overruled the commissioner. The Justice Department appealed, and the case was headed for the Supreme Court in Washington. It was agreed in legal circles that Factor had a very weak case and would be extradited before spring, but Factor was armed with millions in cash and could hire the best lawyers, who managed to delay his hearing until April 1933. Two office employees who had worked in Factor's London bucket shop were arrested, tried and convicted and sentenced to prison. The future for Jake the Barber in London was far from pleasant.

On April 18, 1933, attorney Overmeyer was in Washington, D.C., waiting to argue before the Supreme Court. The newspapers carried stories reporting that Jerome Factor, Jake's son, had been kidnapped. Jake the Barber skipped the Supreme Court appointment in Washington, which he had a good reason for doing. If he had appeared in the District of Columbia, he would have been in federal jurisdiction without the protection of Illinois law, which was keeping him in the United States. In Washington, he might have been arrested and summarily shipped to England. With his son reportedly kidnapped, he had an excellent alibi for

failing to appear in Washington. Nobody would expect a father to leave home in the middle of such a family emergency.

On May 29, 1933, the Supreme Court again assigned the Factor extradition case for a hearing. But English justice would have to wait; Jake was not going to be had easily. Jake tried everything not to extradited back to England. It is presumed that he even faked his son Jerome's kidnapping. About seven weeks after Jerome had been reported kidnapped, he returned home. When that didn't work, Jake faked his own kidnapping.

MELVIN PURVIS SAC IN CHARGE OF CHICAGO FBI

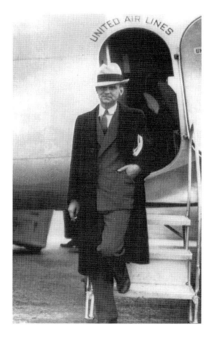

Melvin Purvis, Chicago SAC, led the FBI's hunts for Baby Face Nelson and John Dillinger. *Courtesy of the* Chicago Daily News.

On October 25, 1932, J. Edgar Hoover appointed Melvin Purvis as special agent in charge of the Chicago office of the FBI. Purvis was now the pursuer of the nation's most feared criminals.

John Dillinger was becoming famous throughout the country for his prison escapes and bank robberies. But he was captured once again in Tucson, Arizona. He was bound in shackles and flown to Chicago, where he was transported to an escape-proof prison—the Lake County Jail at Crown Point, Indiana—on January 30, 1934. On Saturday, March 3, 1934, Dillinger escaped again. Hoover wanted Dillinger captured in the worst way. One day, Purvis got a tip that Dillinger and his gang were hiding out at a Little Bohemia lodge near Manitowish, Wisconsin, with associates Homer Van Meter, John Hamilton, John Reilly and Tommy Carroll, as well as Lester Gillis, who was more commonly known as Baby Face Nelson. The Dillinger gang also had four molls with them.

Purvis chartered two planes. Eleven agents departed Chicago with their weapons and bulletproof vests for the three-hour flight. Once they were in Rhinelander, arrangements were made to get transportation to the lodge. Henry Voss, who had called Purvis and told him where Dillinger and his gang were, returned from an errand he had been on. He forgot to tell Purvis about the two collies that barked whenever anyone approached the lodge.

14

THE G-MEN SHOOT THE WRONG MEN

When the agents arrived near the lodge, they left their cars at the entrance gate and were slowly advancing the two hundred yards toward the lodge on foot. Then, the dogs began barking. Purvis was certain that the barking would have alerted Dillinger to their arrival, but in fact, the dogs had been barking all weekend. By Sunday evening, none of the gangsters gave them a second thought. Dillinger never looked up from his card game.

But when the barking began, something more critical occurred. Purvis observed three men leaving the lodge and then two more, five in all. One light bulb was all that illuminated the resort's entrance. Three of the men got into a 1933 Chevrolet Coupe, and the other two remained on the porch.

Little Bohemia Restaurant hideout. In Wisconsin for Dillinger and Nelson, the FBI shot the wrong men. *Courtesy of the FBI.*

Purvis assumed that the three men leaving had to be some of the gangsters in a hurry to leave. He positioned his men. The men in the car switched on the radio to full volume.

The Chevy backed away from the lodge with its headlights off; the driving was erratic, and agents Purvis and Clegg, plus Blum and J.C. Newman, aimed their weapons. "Halt!" yelled Purvis. "We're federal officers." The car kept coming. "Fire!"

Twenty-eight bullets tore into the Chevy, which finally slammed to a stop. The driver-side door opened and a man jumped out and ran into the darkness. Another man fell out of the Chevy and slumped to the ground. The third man remained in the car. Not one of the five men who walked out of the lodge and prompted the shooting was a gangster. Two were employees, and the other three were patrons. Two of the men were wounded, one dead.

15

BABY FACE NELSON ESCAPES
AND KILLS AN FBI AGENT

When Nelson heard gunfire, he could have slipped away out the back of his cabin and disappeared in the woods, since he was the only one not staying in the main lodge. Instead, he came around front and fired wildly in the darkness before running back to the woods and along the lakeshore to a cabin a mile away. The cabin belonged to George Lang and his wife. Nelson had George and his wife drive him in George's 1932 Chevrolet to Koerner's place before it stalled. Nelson had Lang knock on the door, and they all entered. Nelson now had four hostages. Four others showed up looking for warm clothing a few minutes later. He now had eight hostages.

Nelson told them that all he wanted was a ride out of the Northwoods. George LaPorte, who had just arrived, was chosen to be the driver in his car. At that point, FBI agents Newman and Baum arrived. "Who's in that car?" Newman asked. No reply. "We hadn't come to a complete stop when a man jumped out of the front seat of LaPorte's car and pushed an automatic pistol through the open window of our car," remembered Constable Christiansen, who had been picked up by Newman and Baum and was sitting in the front seat beside them. Baum was depressed by the shooting of a civilian at the lodge.

Nelson told them that he knew that they were cops: "I know you have on bullet proof vests, so I will give it to you high and low." Newman tried to grab Nelson's gun and pushed his way out of the car. Nelson opened fire. The first bullet glanced above Newman's right eye, causing him to fall face first to the ground. Then it was Baum's turn. Nelson aimed his gun at

Baum's neck but angled it downward. He knew what he was doing. The bullet sliced into Baum's neck just above his impenetrable steel vest and pierced his heart, killing him. Newman survived his wounds. Because of the death of the civilian, Baum's last statement was "I'll never fire this gun again," referring to his machine gun.

Back at the lodge, where Purvis was still searching for the gangsters, he realized that they were gone. Dillinger and all the others escaped. The raid had gone wrong because the agents missed the embankment. The lakefront was actually nine or ten feet below the level of the lodge. The embankment served as a wall that hid Dillinger from his pursuers. Dillinger jumped out a second-floor window, slipped down the embankment and ran north along the beach between the lake and the woods. Hamilton and Van Meter and the others followed Dillinger and made their escape.

The headlines and editorials were brutal about the FBI raid. A petition demanded that Purvis be suspended pending an investigation of the irresponsible conduct of federal operatives in raiding the John Dillinger hideout in such a stupid manner. To say the least, J. Edgar Hoover was very upset. Melvin Purvis was depressed and thought about resigning from the Bureau. The hunt for Nelson continued. He leisurely crisscrossed the country, driving back and forth between Illinois and California, together with his wife and his pal Johnny Chase—a holdover from the Dillinger gang. On one trip back to Chicago, a police car pulled Nelson over for speeding. The gangster's car was packed with guns and ammunition. But Nelson remained calm, and the officer saw no need to search the car. Nelson paid a five-dollar fine and went on his way.

Hoover and his men continued their search to pin him down. In October 1934, agents from the San Francisco office grilled a woman who was known to be the girlfriend of Johnny Chase. She provided a detailed account of Nelson's travels in Illinois and Wisconsin. In Washington, Hoover decided to put Sam Cowley, his top field agent, on this new information. The woman's information included a clue that Nelson had said where he was going to spend the winter, but she forgot the name of the town, even though she had spent some time there.

The woman was flown to Chicago to see if her memory could be jogged. Special agent Charles Winstead drove the woman through several small Wisconsin towns until they found the one she remembered: Lake Geneva, site of the Como Inn. Hobart Hermanson confessed to harboring Nelson in the past and cleared the way for Winstead and two other agents to set up a stakeout at the inn in early November 1934.

Chicago SAC Purvis (*left*) and FBI director J. Edgar Hoover (*right*). *Courtesy of the FBI.*

On November 25, Nelson returned to Illinois to assemble a new gang for a train robbery. On November 27, Nelson, his wife and Johnny Chase drove to the Como Inn, where they hoped to visit with Hermanson. Instead, they found agent Metcalfe on the porch. While speeding away from the inn, they passed another car, this one driven by another special agent, Colin McRae.

Though McRae saw Nelson only fleetingly, he was quick enough to make note of the Ford's license plate. The Chicago office was called and informed that Baby Face Nelson was in town.

Sam Cowley answered the phone in the bureau office at 2:45 p.m. on November 27. He sent four agents to head to Lake Geneva, including two agents who were manning a phone tap, Bill Ryan and Tom McDade, to watch for Nelson's Ford. Cowley and Ed Hollis followed shortly thereafter. On their way out, Cowley passed Purvis's office, saying, "Baby Face Nelson has just left Lake Geneva."

"Let's get going," Purvis answered, rising from his desk. "It won't be necessary," Cowley said. "Hollis and I are just going to cruise around to see if we can spot the car on the highway. When we get set, I'll phone you." Purvis volunteered to call Washington, but Cowley said, "Don't bother, as the information is rather vague." Purvis called anyway.

On Route 12, agents Ryan and McDade spotted Nelson's Ford sedan speeding on the highway. They were in a Ford coupe, stopped by the side of the road. Ryan and McDade made a U-turn to pursue Nelson, but seconds later, Nelson made his own U-turn and drove back toward the agents. When he passed them, he made another U-turn across the grassy median—now he was chasing the agents. Nelson drove alongside the agents and told them to pull over, as if he were an authority, waving a pistol at them. The agents sped away. Nelson then fired at the agents; Ryan returned fire, squeezing off seven rounds.

Nelson started yelling at Chase to start firing his rifle at the agents through the windshield of Nelson's car. Helen Gillis felt shards of glass rain on her head, she later told the agents. The next thing she heard was her husband saying, "They must have hit the motor; we are losing speed." Ryan and McDade radioed reports of the shootout to Purvis in Chicago. Purvis notified local police of this situation and the location of the shootout. Purvis received another report from Hollis and Cowley that they had just passed Nelson's car and were making a U-turn to join the chase.

Ryan and McDade, who were farther ahead, pulled over and hid in the roadside grass, hoping to ambush Nelson. Nelson spotted Hollis and Cowley gaining on them from behind and made a quick right turn on a dirt road beside the highway outside Barrington, Illinois, and stopped suddenly.

Helen jumped out and ran into a field along the road and lay down. Hollis was following Nelson onto the dirt road, barely decelerating as his car made a sharp turn off the highway. Hollis didn't know that Nelson had slammed

on his brakes and parked the car. He expected the chase to continue. He was fifty yards past Nelson's car before he hit his own brakes. Nelson and Chase were already out of their car and poised to shoot. Cowley and Hollis had driven into a trap.

Before they got out of their car, Nelson and Chase were firing at the car. Cowley began firing his submachine gun, and Hollis fired his Winchester. It was twilight; the flash of their guns lit up the sky, and the sound brought several bystanders out of two nearby filling stations.

Nelson's attack was relentless, and he brazenly left the cover of his car, firing his bolt-action rifle. He walked toward Hollis and Cowley, firing as he went. Chase remained behind the cover of his car. Nelson was near Cowley's Hudson. Herman Hollis lay dead from a bullet wound to his forehead. Sam Cowley was in a ditch by the side of the road, badly bleeding from wounds to his stomach and chest. Nelson seized Cowley's Hudson, driving it to Chase and instructing him to retrieve the other weapons. Helen returned to the car as well. That's when Nelson told Chase he had better drive—as he had been shot—and they then escaped.

Cowley was taken to Sherman Hospital in Elgin, Illinois, by a bystander who happened on the scene. Purvis was notified of the shootout, Hollis's death and the badly wounded Cowley's hospitalization. Purvis rushed to the hospital and found that Cowley was in the operating room in critical condition. Sam Cowley died from his gunshot wounds at 2:17 a.m.

Hoover was very upset. Baby Face Nelson had now killed three federal agents in the past six months. When Hoover learned of the shooting, he called inspector Hugh Clegg in Pittsburgh to come to Chicago and take charge of the entire situation.

On November 29, an undertaker in Niles Center, Illinois, thirty miles from Chicago, took an anonymous call claiming to know where a body could be found. The undertaker notified the chief of police, who in turn called the FBI. The police found a naked body wrapped in a blanket in some weeds in a ditch on the corner of Long and Niles Streets. Nelson had died at 7:35 p.m. An autopsy showed that Nelson died from nine wounds caused by bullets from the guns of Hollis and Cowley.

John Chase managed to elude the police and federal agents until he was captured by the police in California on December 27, 1934. He was charged with the murder of Sam Cowley, found guilty and sent to Alcatraz. After serving twenty years, he was sent to prison in Leavenworth and paroled in October 1966. He returned to California, where he died of cancer on October 5, 1973.

16

TOUHY AND PALS ARRESTED
FOR THE WILLIAM HAMM KIDNAPPING

On June 15, 1933, Capone had corrupt law enforcement official Tubbo Gilbert arrest Touhy for the kidnapping of William A. Hamm, the brewery heir. In fact, the kidnapping had actually been committed by the Barker brothers, working with gangster Alvin Karpis.

The FBI already had evidence that the Barker-Karpis gang had kidnapped Hamm (who was freed four days later after paying a $100,000 ransom). Touhy and three of his friends had been on a fishing trip in northern Wisconsin. These friends, McFadden, Stevens and Sharkey, spent most of their time carousing in local taverns, on occasion getting over-served. Willie Sharkey tried to get every Indian drunk and do war dances. It was against federal law to give liquor to an Indian, and Willie was flirting with an Indian maiden whose boyfriend was a six-foot brave. Touhy didn't want to see Willie's scalp hanging from the brave's belt, so he decided it was time to head home.

A light rain began falling, and the road was slippery, causing Touhy's Chrysler to skid off the road, hitting a wooden telephone pole near Elkhorn, Wisconsin. Touhy waited until a deputy sheriff came along. The deputy said it would cost $22.50 to repair the pole. Touhy agreed and went with him to settle up, and the other three saw a saloon and went there to wait for him. While they were gone, another cop searched the car and found some guns under the rear seats. The four men were arrested after the police also found some papers and recognized the name of Roger Touhy. Nobody would explain why they had been put into a cell, but then they heard that while

they were in the north woods, Tubbo Gilbert had issued a statement to the press saying that he had evidence to prove Touhy guilty beyond a doubt of kidnapping Hamm and Factor.

Touhy had been without news or a phone while up at the north woods and was shocked.

The FBI agent in charge of the Chicago office, Melvin Purvis, finally informed Touhy that he was being held for the Hamm kidnapping. Touhy was perplexed and questioned Purvis as to who was he talking about. Purvis explained that William Hamm Jr., a millionaire brewer of St. Paul, Minnesota, had been kidnapped outside his place of business on June 15. That had been fifteen days before Factor's reported snatch. The rap now was being charged up to McFadden, Stevens Sharkey and Touhy.

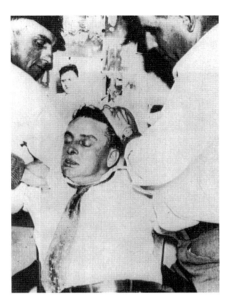

Touhy was beaten while in FBI custody. *From* The Stolen Years, *by Roger Touhy*.

Touhy recalled he had a solid alibi for June 15 and informed Purvis so. Touhy told Purvis he was making a big mistake accusing them of the Hamm and Factor kidnappings and he hadn't been in Minnesota in over two years. Purvis did not answer him. Within a few hours, Touhy had handcuffs on his wrists for the first time in his life. The cuffs were attached to an escape-proof safety belt around his waist. McFadden, Stevens, Sharkey and Touhy were transported to Chicago, where they were fingerprinted and photographed in the Bankers building FBI offices. One by one, they had to stand in a door with a one-way mirror so they couldn't see anyone, but Touhy found out that Jake Factor could see them.

From the FBI offices, they were taken to Chicago Police Headquarters, where Chief of Detectives Bill Shoemaker and Lieutenant William Blaul were assigned. They were two honest police officers and told Touhy and the others that they were going to give them a fair show-up. Touhy, McFadden, Stevens and Sharkey, who were still handcuffed, were put on a raised platform with bright lights shining down on them.

Out in front of them in the darkened auditorium were victims of various crimes. They could see them, but Touhy and his friends could not see them.

They were told to move every which way by an officer with a microphone. They all had to answer questions as well, so the witnesses could try to recognize their voices. When it was over, Shoemaker told Touhy, "You men are clean as far as we are concerned. Nobody fingered you in the show-up."

He also informed Touhy that Jake Factor was in the audience. The FBI then transported them back to Elkhorn, Wisconsin, when FBI Agent Purvis informed them that he had warrants charging them with kidnapping Hamm. It was a federal offense, he said, because the evidence was that Hamm had been taken across a state line from Minnesota to Wisconsin. They were liable to life terms in prison under the Lindbergh anti-kidnapping law if they were convicted in St. Paul. It was stupid to charge Touhy and his friends with the Hamm kidnapping; they really knew nothing about it and were being framed.

Jake the Barber had viewed Touhy, McFadden, Stevens and Sharkey in Chicago at the FBI offices and the Chicago police show-up. They were told that nobody had fingered them by the Detective Division. There was no way that Captain Dan "Tubbo" Gilbert of the State Attorney's Police and State's Attorney Thomas Courtney would have allowed them to be taken away to another state on the Hamm case. Gilbert and Courtney wanted all the headlines and glory of a kidnapping conviction. Every cop and prosecutor in America would love to say they were responsible for the capture and conviction of kidnappers. Of course, Jake Factor would also be delayed on his return to England to start serving his sentence.

The FBI transported Touhy and Company in chains to the Milwaukee County Jail, where they were put in separate cells in maximum security. They were not allowed any visitors—no consultations with attorneys, no radio broadcasts, no newspapers. Part of the FBI's rehabilitation of prisoners was to abuse and beat them. They wanted Touhy to confess the Hamm kidnapping, so he was not allowed to rest for more than half an hour. When he slept, a few interrogators came to his cell and beat him against the wall. When Touhy left the jail, he had lost twenty-five pounds, seven of his teeth had been knocked out and three vertebrae in his spine had been fractured.

TOUHY AND COMPANY INDICTED FOR HAMM KIDNAPPING

On August 13, 1931, a federal grand jury in St. Paul indicted all of them for kidnapping. They were taken back to St Paul in chains to the Ramsey County Jail. The beatings stopped, but they were back in maximum security, where they would remain until the trial. Touhy had a visitor one day, a former Ramsey County prosecutor in St. Paul, Thomas McMeekin, who was an able lawyer. He said that he had been retained by the Stevens family about a California matter. He said, "You and your friends need a lawyer in the Hamm case, but I'm not applying for the job. I will get a lawyer of your choice if you like."

Touhy asked him to get in touch with William Scott Stewart in Chicago. Touhy knew that they would need a local lawyer besides Stewart. McMeekin replied, "Not me Touhy, Bill Hamm is a good friend of mine."

Touhy pleaded with McMeekin and swore that he was innocent and had an alibi that couldn't be beaten. Touhy told him about his family and that he had no previous criminal record. McMeekin said that he wasn't convinced, but he would think about it. McMeekin contacted Stewart, who came to see McFadden, Stevens, Sharkey and Touhy. McMeekin paved the way for the visit with the authorities. Touhy asked Stewart to take in McMeekin as co-defense lawyer, and he agreed. Touhy asked Stewart to send his wife up to see him, as he had very important facts about the case and she would understand what to do.

Clara came up to visit Roger without any trouble. They put them in a room with two FBI men also present listening to every word and making

notes. Touhy asked if it would be OK if he held his wife's hand, as he hasn't seen her in a long time. They nodded and gave their OK. Clara and Roger held hands and began telegraphing each other. A short pressure of a finger was a dot and long pressure a dash. They had practiced it often when talking secretly in front of their sons. Vocally, Touhy rambled on about things that made no sense. Clara understood him perfectly. In Morse code, he told her to get in touch with Edward J. Meany, a suburban real estate dealer Touhy had known for most of his life.

Touhy recalled that Meany had come to Touhy's home on June 15, the date of the Hamm kidnapping, and invited him to his daughter's graduation exercises that evening. Touhy also wanted Clara to check with the Claypool Hotel in Indianapolis where he had stayed overnight. The two FBI men never wrote anything down that caught their interest.

The St. Paul trial was a fiasco. When the trial started, newsboys were selling the St. Paul and Minneapolis newspapers in front of the courthouse. The headlines said that McFadden, Stevens, Sharkey and Touhy had been indicted in Chicago for kidnapping Jake the Barber. The prospective jurors reporting for duty at the trial couldn't help but see the headlines.

The stories said that they were mobsters, murderers, bank robbers and thieves. There were scores of people around the courthouse who saw them manacled and chained from the jail to the court. Police with machine guns and riot guns were everywhere. Stevens told Touhy to look over his shoulder in the front row, where he saw Tubbo Gilbert and Jake the Barber. Touhy knew Gilbert and never had seen Factor before but recognized him from photos in the newspapers.

18
THE HAMM TRIAL

The Hamm trial began with the man himself, who seemed honest. He told the courtroom how he was kidnapped in front of his brewery in broad daylight. Hamm said that a man resembling McFadden had taken him by the hand to the getaway car. The defense attorneys got Hamm to admit that he once had identified Verne Sankey, a notorious bank robber, as the man who had taken him by the hand. Under cross-examination, Hamm, an honorable man, said that he didn't know for sure if McFadden was one of the kidnappers. He added that he had never seen Stevens, Sharkey or Touhy as far as he knew.

U.S. Attorney General Keenan sprang a surprise witness on Touhy and his co-defendants. The witness was a printer from Chicago who said that he was in St. Paul looking for a job on June 15 but hadn't found one and had gone out to the Hamm Brewery. He was always interested in breweries, he said. He swore that he went to a nearby store to buy cigarettes and returned in time to see Hamm kidnapped.

He identified McFadden, Stevens and Sharkey as the kidnappers, and by implication, that meant Touhy was the fourth one. The printer just thought they were all drunk, and he went back to Chicago that night. He then read about the Hamm kidnapping in the paper and wrote a letter to the U.S. attorney in St. Paul. He carried the letter around for about four weeks without mailing it. He then read about the Touhy and his friends' arrest in Elkhorn and mailed the letter.

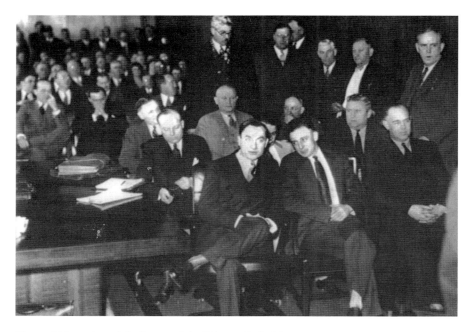

Hamm kidnapping trial. *Courtesy of the* Chicago Daily News.

Touhy told attorneys McMeekin and Stewart to get in touch with the Dannenberg Detective Agency in Chicago and have it check out the printer. The agency did so and found that the witness had been working as a printer in Chicago at the time he claimed to have witnessed the kidnapping in St. Paul. The payroll records proved beyond question that the printer was a liar and perjured himself. Was the printer ever charged with perjury? Nope.

Touhy's real estate dealer friend Meany did get to testify and swore that on June 15 he had invited Touhy to his home to attend his daughter's graduation exercises. The prosecution gave him a vicious cross-examination, but he wouldn't budge an inch. He testified that a Chicago FBI man came to him with a warning: "If you testify in St. Paul for Touhy, you'll be sorry, and maybe you won't come back." Meany did testify, and Touhy and his crew were found not guilty. The truth subsequently came out that the kidnapping had actually been committed by the Barker brothers and gangster Alvin Karpis. The FBI had substantial evidence that the Barker-Karpis gang had kidnapped Hamm (who was freed unharmed four days later after payment of $100,000 ransom). There was nothing but hearsay linking Touhy and his friends to the crime. Nevertheless, Touhy and the three others were still indicted on kidnapping charges. They were found

not guilty on November 28, 1933. While awaiting their release after the Hamm kidnapping trial, Touhy was arrested again on December 4, 1933, this time for the kidnapping of John "Jake the Barber" Factor, brother of cosmetics mogul Max Factor.

The people of St. Paul had been conned by the press and seemed to regard the printer as a reliable witness. There was a loud crowd gathering around the jail that night. Touhy was in fear for his life, and so were the others. In an effort to protect Touhy, his attorney pleaded for police protection for his home when vigilantes began to gather there. Two years later, Touhy wondered how the angry mob felt after Dillinger, Barker and Karpis pleaded guilty to the Hamm kidnapping.

McFadden, Stevens and Touhy were returned to Chicago in chains. Willie Sharkey was so bothered by his incarceration for the Hamm kidnapping that he hanged himself with his necktie in the Ramsey County Jail. Touhy admitted that he wept when he heard about it. Touhy, McFadden and Stevens were put in the Cook County Jail. McFadden, who was indicted with Touhy and Stevens, had been in the Oak Park hospital the entire time that Jake the Barber claimed to have been in the hands of the kidnappers, but then again, there never had been a kidnapping anyway.

19
THE FACTOR FRAME UP

T he Factor kidnapping was a frame up. Factor had arranged to fake the kidnapping and produce evidence implicating Roger Touhy in order to eliminate him so the Capone gang could take control of his operation. The plan was risky; Factor was a known mobster on the run from British authorities on mail fraud charges. His case was in front of the Supreme Court, but if he was kidnapped, he couldn't be extradited. Factor was having his troubles in July 1933. As previously mentioned, the British government had been trying to extradite him to England for more than two years. His majesty's counsel claimed Factor had mulcted George V's subjects of more than $7 million.

Allegedly, Factor had vanished for twelve days in July. He testified that he had been at a gambling club called the Dells located at Dempster and Austin Avenues in Morton Grove on the night of June 30, 1933. As he left the Dells at about 1:00 a.m., he recalled that two cars overtook him on Dempster a few blocks east of the Dells and pushed the car off the road. Several men grabbed him and put him in another car, where he was blindfolded. He was taken to a house in Glenview, where he was tortured and beaten by his kidnappers.

Negotiations for Factor's release ended when Factor's wife paid $75,000 ransom on July 12, 1933. Touhy and Stevens were going on trial. The prosecution ran in a substitute for Sharkey: Albert Kator, who had driven a beer truck for Touhy. He didn't know why he had been fingered, and Touhy agreed with him. If Factor hadn't falsely identified all of them, they wouldn't have been indicted in the first place.

Con man Factor faked his own kidnapping to avoid extradition. *Courtesy of the CPD.*

Touhy couldn't understand why McFadden had been indicted with them because he had been in the hospital during the entire time that Jake the Barber claimed to have been in the hands of the kidnappers. McFadden had numerous witnesses at the hospital to back up his alibi.

This whole thing was getting crazy. The local newspapers gave them all nicknames. McFadden had become "Father Tom"; they were calling Touhy "Black Roger" and "Terrible Touhy" and claimed he was a machine gunner, a bomber, a murderer and a few other stupid names. Kator was called "Polly Nose"; Stevens, indicted under a phony name, was called "Gloomy Gus." The press previously had called Jake the Barber the international swindler at the time of the alleged kidnapping. But now, with the trial coming up, he wasn't Jake the Barber anymore. He became John Factor, international speculator. The papers and the bosses of the Associated Press, International News Service and the United Press felt for the first time that there was a chance in America to finally convict a vicious kidnapping gang.

The Cook County state's attorney, Courtney, probably believed at the time that Kator, Stevens McFadden and Touhy were guilty. Courtney was totally inexperienced in prosecuting and doing investigative work. He was a political office holder and had to rely on what Dan "Tubbo" Gilbert told him.

Courtney was publicly committed to a conviction, and the glitter and positive publicity hadn't worn off the handsome, boyish, dimpled state's attorney. Thousands of Chicagoans believed he was the Wyatt Earp who was going to clean up their city and smash the Capone mob. It was the popular thing to hate the kidnapers. But in modern times, if someone like Jake the Barber tried to fake a kidnapping in Chicago, the dirty work undoubtedly would be exposed within forty-eight hours.

If the police and the FBI messed up, the newspaper and television investigative reporters would do their job and expose the fraud. In 1933, the publicity against Touhy and his co-defendants was really bad. Touhy

and crew were called mad dogs, while Factor was being almost treated like a hero, considering his criminal past history. Touhy really got shook up one day when he picked up a newspaper with a headline in very large print: "STATE TO SEEK DEATH FOR TOUHY GANGSTERS."

Stevens saw the same headline and said, "Rog, maybe you can get Tubbo to hold your hand when you sit down in the chair and they turn on the juice." Touhy and his co-defendants were taken from the county jail to the criminal courts building through an underground passage that had been called "the tunnel of hopeless men." They rode in a special elevator and were put in a cage at the rear of the courtroom. A group of photographers was waiting and took their pictures. They looked like public enemies with their stubble and wrinkled clothing—more pictorial propaganda for the prosecution. The trial was assigned to Judge Michael Feinberg. They pleaded not guilty, and Touhy, Stevens, Kator and McFadden were returned to their cells. Christmas was coming, and attorney Stewart said bye-bye; he was going on a vacation over the holidays. The newspapers announced that every jail inmate would be served a turkey dinner.

Roger notified Clara not to send any special food for the holidays since they would be feasting on a traditional Christmas dinner, including turkey and all the trimmings. Not a bad dinner for being in jail.

TUBBO GILBERT

The Richest Cop in the World

Gilbert came from an area in the city called the Valley, the same area where the Touhy family came from. Gilbert grew up to be one of the most politically powerful and wealthiest lawmen in American history. He got to be known as "the richest cop in the world." In 1913, as a young man, he went to work at the train depot that once dominated the valley center. He then ran for and won a position as the secretary of the baggage and parcel delivery union, Local 725. His opponent withdrew in the middle of the election on Christmas night. On April 6, 1917, the governing council of the mobbed up Chicago teamsters union used its political influence to have Gilbert appointed to the Chicago Police Department.

While on the force, he pursued a separate career in union politics, keeping his position on Local 725. As a cop, Tubbo earned a reputation for brutality, but he was smart enough to surround himself with brighter and more capable underlings. During one wildcat strike called by the membership without his authority, Gilbert beat the strikers' leader so badly he was indicted for assault with intent to kill. Of course, the indictment was later suspended with leave to reinstate. However, the records later disappeared mysteriously from the criminal courts building.

Gilbert's rise on the police department was unprecedented. After less than five years as a patrolman, he was promoted to sergeant; a year later he was a lieutenant and, shortly after that, captain.

At that point, he was promoted to the chief investigator of the State Attorney's Office, with one hundred investigators under his command. He held this post for eighteen years.

Later, Judge Barnes stated, "Captain Gilbert and Factor have sought to explain Factor's many statements...by saying that the FBI agents and Captain Gilbert instructed him to lie. So far as the FBI agents are concerned this statement is impossible to believed. There is no way that an FBI agent would ever tell a prospective witness to lie under oath."

As far as Tubbo Gilbert is concerned, he told so many lies that anything was possible. Gilbert became involved in many scandals. Once, during a citywide election, Gilbert found out that one of his investigators was a spy for Mayor Edward J. Kelly's camp. Tubbo took the cop into his office and beat the man senseless with his fists. Charges were filed, but again they were dropped. Again, all records concerning the charge disappeared.

In another scandal, Gilbert was questioned about his role in helping the mob-controlled Chicago teamsters fix milk retail prices in Chicago. The scandal also involved Dr. H. Bundesen of the Chicago Board of Health and officials of Local 753 of the milk drivers' union. State's Attorney Thomas Courtney refused to request Gilbert's resignation.

At one time in 1935, Courtney and Gilbert were both accused of using the State Attorney's Office to harass a political leader named Harry Perry, who was also an alderman. Perry publicly reported that he was in fear for his life, and on March 24, 1935, after Perry filed a formal complaint against Courtney and Gilbert, he was driving home from a political rally on the south side with two Chicago detectives as bodyguards. All at once, a dark sedan pulled up alongside Perry's car, and a pistol fired from the back seat let off eight rounds into Perry's car, which swerved out of control and crashed. Remarkably, no one was hurt, but Perry withdrew his complaint against Courtney and Tubbo Gilbert the next day.

In 1935, the mob almost had its own police chief when Gilbert temporarily left his job in the State Attorney's Office to take a job as commander of uniformed patrol. This position placed him one step behind the chief of police. The position also made him the boss of the vice and gambling units. A few months later, Gilbert stepped down from the uniformed position and returned to the chief investigator's post—after disbanding the gambling squad.

Most Chicago crime reporters were of the opinion that Tubbo Gilbert was a full-fledged member of the Chicago crime syndicate, answering only to Murray Humphreys, a mob boss. The *Chicago Tribune* opposed Gilbert when he ran for Cook County sheriff and published records found in the oven of the mob's money man, Jake Guzik, when he moved out of his apartment. These documents summarized profits and losses of gambling for a month. It

also listed payoffs: "Tub...$4,000." Gilbert denied the charges by explaining that his friends call him "Tubbo," not "Tub." So it couldn't have been him.

Gilbert's résumé goes on and on. It was amazing to Roger Touhy that a chief investigator for the Cook County State Attorney's office would tell so many lies about the Hamm kidnapping and falsely accuse Touhy and others when he knew they had nothing to do with it. There is no doubt that the influence of Daniel "Tubbo" Gilbert, along with the Al Capone Chicago crime syndicate, played a role in Touhy being indicted.

Touhy recalled that when he was a boy, a priest, Father Goodwin, explained an oil painting of the last supper. He told him about a man called Judas, who had betrayed Jesus Christ for thirty pieces of silver. That information stuck in Touhy's mind for the rest of his life. Obviously, Judas was a stool pigeon.

21

PERJURY AND MORE PERJURY

The night of June 30–July 1, 1933, remained in Touhy's mind forever. That night, Touhy went to the Oak Park Hospital to visit his brother Tom, who was there for treatment, and "Chicken" McFadden, an old union friend, who was recovering from a prostate operation. He had picked up two of Tommy's daughters and brought them with him. Touhy told McFadden to get well, as Clara, the kids and he were going fishing in Wisconsin in a few days and wanted him to come along.

The Touhys had a house guest that night, Emily Ivins, the woman who had been Roger and Clara's chaperone when they'd first dated fifteen years ago. Clara, Emily and Roger sat on the front porch in semidarkness. The kids were sleeping. Emily knew that she could stay with them as long as she wanted but would only stay for a few days. It was Friday, and they wouldn't eat meat until after midnight, which would be Saturday. After midnight, they had sandwiches and coffee, obeying the Roman Catholic rules. This was the time Jake the Barber claimed to have been kidnapped by Touhy and his men. Clara, Emily and Roger talked until about 4:00 a.m.

Touhy hated kidnappers. The Lindbergh kidnapping was horrible, and there was a national hysteria against kidnappers. No kidnapper had ever been captured, prosecuted and convicted during the wave of kidnappings. Every police officer and prosecutor in America wanted to solve a kidnapping. He asked some people he knew if they had seen or heard of anything unusual about Jake the Barber being kidnapped—every response was negative. One report he did get was that Jake the Barber and mob boss Murray Humphreys

were friends. Touhy began to wonder if the Chicago mob might be setting him up as a patsy for a kidnapping rap.

He had an alibi from the people in the hospital, including Tommy, his two daughters, McFadden, the doctors and nurses. Besides, when the purported kidnapping was going on, Touhy had been sitting on his porch with Clara and Emily Ivins.

A representative of the British Crown in Chicago reported that the kidnapping was a fake engineered by Factor to beat extradition. But then Tubbo Gilbert, the most powerful law enforcement officer in Cook County, muscled into the picture with a newspaper blast. He announced flatly and firmly that the kidnapping was legit and the "Touhy gang" had kidnapped Jake the Barber. He didn't qualify the accusation. He simply said that Roger Touhy was the man to get for the crime.

There were two witnesses for the prosecution, the first of whom was Eddie Schwabauer, a guy who drank too much and never held a job for long. Schwabauer was a former employee of Touhy's. Touhy fired Schwabauer in June, about three weeks before Factor "disappeared." Touhy had hired Eddie to guard his home at night after the attempted kidnapping of his two sons.

Eddie testified that he had gone on duty at Touhy's home between 9:00 and 10:00 p.m. on June 30. This was Eddie's first lie. He had been fired by Touhy, who had replaced him with another guard. Eddie testified that he hadn't seen a living soul around Touhy's home all night, there weren't any lights on in the house and nobody was on the front porch.

Touhy was surprised when Buck Henrichsen was called to testify. Touhy had always treated Henrichsen very well. When he was broke and out of work, Touhy gave him a job. In February 1933, he came crying to Touhy that a credit company was going to repossess his household furniture for nonpayment of installments. Touhy gave him $200 or $300 and paid his grocery bills. His wife, Helen, even sent Roger a thank-you note.

Weeks before the trial started in Chicago, Touhy's friends told him that they believed Buck had sold out to the State Attorney's Office. He had been living at the Oak Park Arms Hotel and the Palmer House, eating steaks at the prosecution's expense.

Touhy couldn't believe it, but it was true. Tubbo Gilbert had given Buck expensive tastes. When he took the witness stand, he was ashamed but went right along with the show to put Touhy, Stevens and Kator in the electric chair. Buck also testified that he had seen Touhy on June 30 in the evening—before Jake the Barber had himself snatched. He was in Jim Wagner's saloon in the

early evening and said that he saw Touhy there along with Stevens, Banghart, Sharkey, Kator and others. Buck said that he got word from Touhy to meet him at Porky Dillon's home on July 5. He did and found Touhy with Dillon, Stevens, Kator and Sharkey. Roger told him to go to the Dells and pick up a man named Joe Silvers. Silvers was one of the managers in the place the night Factor disappeared.

Touhy's attorneys were never able to find Silvers to use as a defense witness. He went to Florida and vanished like a guy who was murdered. Rumor was that he was put in a cement shroud and dumped in the Atlantic Ocean.

Buck testified that Touhy had given him $1,000 and told him to buy a car. The innuendo to the jury was that the money came from Jake the Barber's ransom. That just about wound up the prosecution's case.

There had been positive identification of Stevens, Kator and Touhy by Factor. Schwabauer and Henrichsen had dirtied up Touhy, Kator and Stevens, but nobody except Jake had accused them of kidnapping. The big question was, why did Henrichsen tell lies about Touhy? It will be shown later that he was rewarded by the Capone mob.

As for Schwabauer, Factor's money and Gilbert's power overcame him. When the prosecution rested its case, Prosecutor Crowley asked the court to dismiss all charges against McFadden. Judge Feinberg granted the motion. McFadden heard that and left the courtroom immediately; he had a belly full of being tried for kidnappings he knew nothing about. McFadden was no longer needed by Crowley, Courtney or Gilbert. His presence as a defendant had served its purpose. Having used to tie Touhy up with the house in Glenview, his usefulness was ended. Touhy's defense attorneys began calling witnesses. Emily Ivins testified to sitting on the front porch with Clara and Touhy until shortly before dawn on July 1. She was positive and unshaken by Crowley's cross-examination.

Another defense witness was a River Forest policeman, Bernard F. Gerard, who was in a car parked at the curb on Burlington Avenue on the night of July 12 when Jake went up to the car, identified himself and asked to be taken to a telephone. This was twelve days after he had vanished from the Dells and came back into public view.

Gerard took Factor to the LaGrange police station. Gerard was a very observant police officer and noticed Factor was wearing a clean white suit that appeared to be freshly pressed except for a slight wrinkling at the knees and elbows. His white shirt was unwrinkled and not soiled in the least. He also had a manicure, his face and hands were clean and his shoes were polished.

Factor did not have any bruises or visible marks. Gerard had an excellent memory and filed all these things away in case he would have to testify in court, which he did later on at the trial of Touhy and his co-defendants. The police station was soon mobbed by reporters and photographers.

Gilbert showed up and took charge. Factor gave a brief interview before Gilbert took him away to the Factor apartment in the Pearson Hotel.

22
FACTOR'S PERJURED STORY

Factor stated that he had indeed been kidnapped and held for twelve days in a house outside of Chicago. He said that he'd suffered terribly; the kidnappers refused to let him bathe, change his clothing, shave or take off his shoes. He was blindfolded constantly, except for a few minutes when he wrote a ransom note. Officer Gerard was cross-examined by Crowley and went through an ordeal that might have driven a normal man into an insane rage. Crowley hinted that Gerard lied and he wasn't fit to be a police officer.

When Gerard left the courtroom, Gilbert's policemen grabbed him outside the door. They took him to Tubbo's headquarters on the second floor of the criminal court's building. Sworn testimony showed that later, Gilbert called Gerard a liar, told him he would be fired and said he had no right to testify as a defense witness without notifying the State Attorney's Office.

While Gerard was being berated by Gilbert, Gerard later testified, Jake the Barber walked into the room and told him, in effect: "I will break you if it's the last thing I ever do, even if it takes every last cent I have." For months thereafter, Gerard's life was made hell. He was tried before the River Forest Civil Service Commission on charges probably pushed by Gilbert. Efforts were made to fire Gerard from his job. He said that he had only told the truth, and the commission exonerated him. Gerard later became the chief of police in River Forest, one of Chicago's finest suburbs.

Stewart bore down hard on Jake the Barber's testimony that he saw Touhy standing behind the blanket immediately after his blindfold was lifted so he

could write the ransom note. One of Touhy's witnesses was an eye specialist who said it couldn't have been possible the way Jake had said it had.

The specialist testified that the human eye takes at least four or five minutes to adjust to the point of being able to see a face under such circumstances, and the prosecution couldn't budge him on cross-examination. Crowley appeared to be a little concerned at that point.

Probably the best of Touhy's witnesses was Father Weber, a peppery, elderly and thin white-haired man. Father Weber testified that he had been with Touhy in his home on July 8, and he was convinced Touhy had nothing to do with Jake the Barber's vanishing act. He said that he believed that Touhy was being framed.

When Crowley asked Father Weber whether he didn't realize that Roger Touhy was a law-violator—a bootlegger—Father Weber took a long look at the jury box and the crowded courtroom and answered the question. "I knew that Roger Touhy sold beer, and I also know a lot of good people who drink it." Father Weber reported truthfully that Touhy had knelt in prayer with him for the safety of Jake Factor, and Touhy also had sworn on the lives of his two boys that he had nothing to do with the kidnapping.

As the trial moved toward a close, somebody told Touhy that Stewart had gone to lunch with Crowley and he chatted with Tubbo during the court recesses. Touhy wanted to go to the witness stand, tell his story and deny guilt. Attorney Stewart strongly advised Touhy against it. If he testified, Stewart said that he would have to call Stevens and Kator as witnesses, because he represented them as well as Touhy. They had records for felony convictions, of course, and he couldn't take a chance of subjecting them to cross-examination, which would bring out their pasts and dirty up everybody concerned.

Touhy talked over the situation with Kator and Stevens in the jail. They told Touhy to go ahead and testify. Their idea was that if Touhy, who was being maligned as "Black Roger" and "Terrible Touhy," could prove his innocence by testifying, they wouldn't be convicted either. Touhy realized that he was the number one defendant, and if the jury acquitted him, Kator and Stevens would most certainly go free with him.

Stewart, although he knew Touhy was innocent, wouldn't listen to him. His records in defending criminal cases showed that he seldom put a defendant in the witness chair. Touhy threatened to stand up in court and demand of the judge that he be heard. Stewart said that if Touhy did that he would walk out of the court. The squabbling between Touhy and Stewart was endless. It was now time for the final arguments.

Stewart and Crowley spoke for hours, pleading and cajoling. Stewart concentrated in his summation on showing that Jake was a liar and a swindler, impossible to believe. He pointed out the fact that Factor had lied to the press, and he hammered at the eye specialist's testimony to show that Jake had lied in court.

He challenged the jury to believe Schwabauer's testimony against Miss Ivins's sworn statement that she had been with Touhy and his wife, Clara, through the crucial hours on the front porch. The testimony by Father Weber and Officer Gerard got a thorough review. Stewart screamed frame up by Jake the Barber and the Capone mob. He went over Touhy's protection for the labor union executives from the mob, the effort to kidnap Touhy's children and everything else he had been able to get on the record through direct testimony or cross-examination. That ended the defense's argument.

23

PROSECUTOR CROWLEY'S ORATORY TO THE JURY

Prosecutor Crowley jumped to his feet, slapped his fist against an open palm and began: "Men, this is serious business—mighty serious business." That set the tone for Crowley's finale to the jury. He went through every form of oratory from a muted whisper to a mighty roar. Kidnapping, he said, was the dirtiest crime on the books. He talked about motherhood and the sanctity of the home. Crowley closed with the recommendation that the jury send all the defendants to the electric chair. Now it was Judge Feinberg's instructions to the jury on the law in the case.

He expounded at great length. He went over some of the testimony. He explained to the jurors that if they had a reasonable doubt—but not a silly, ridiculous or dubious doubt—as to the defendants' guilt, then the verdict should be "not guilty." If there was no reasonable doubt, then a conviction was in order. He explained that in Illinois, a jury, in addition to deciding guilt or innocence, sets the penalty in a capital case.

The judge pronounces the sentence, but the jury decides it. Judge Feinberg explained that, in case of a guilty verdict, the jury could sentence them to:

1) Life in prison (Under such a term, they would be eligible to apply for parole after 20 years, under an Illinois Supreme Court decision.)
2) Any number of years in prison from 5 to 199 (they would be eligible to ask for parole after serving one third of the set term; after 10 years on a 30-year term, for example.)
3) Death.

The jurors returned to their room to deliberate. Stevens, Kator and Touhy sat around in the prisoners' bullpen off a corridor at the rear of the courtroom for a few hours. Then officers took them back to the jail, offered them food—which none of them could eat—and locked them in their cells. The bad news was that the Factor jurors had found them guilty but were unable to agree on the penalty. Maybe they were eleven to one for the death penalty, with the lone juror demanding 199 years instead of the chair. Or maybe they might be eleven to one for acquittal, with one juror holding out for the 5-year minimum.

After twenty-four hours, the guards and bailiffs handcuffed the defendants and took them back to court. Touhy asked if there was a verdict, and one of the guards tipped them off. "Naw," the jury seems to be deadlocked. "The judge is calling them in to inquire, keep calm." The jurors filed into the box, and Touhy gazed at the all-too familiar faces. Touhy, Stevens and Kator had looked at them a lot in the weeks-long ordeal. The trial had started on January 11, and it was now February 2. Several of them looked at Touhy sympathetically as the returned to the box, and the accused felt heartened. Maybe, just maybe, the jurors believed them by eleven to one, and they would be free in a few hours after the twelfth was won over. Judge Feinberg inquired of the jurors if they had selected a foreman. They had. The foreman stood up. The judge asked if a verdict had been reached. "Not yet," the foreman replied. The answer seemed to Touhy to mean that there was hope for agreement and the jury would be sent back to deliberate some more. He was quite hopeful for a minute or two. Bang! Down came Feinberg's gavel. He discharged the jury. Stewart tried to protest, but he got no attention. His Honor had spoken. The trial was ended, but there would be a new, long and expensive retrial.

Touhy looked around the courtroom and saw his two worst enemies. Tubbo Gilbert was rubbing his chin. Jake the Barber was showing his big white teeth in a wide smile. Judge Feinberg's ruling meant that he could remain a fugitive from England for the duration of the second trial and for the appeals in the case of a conviction.

24
TOUHY'S RETRIAL

After the first trial, Touhy fired Stewart. "Scott, you know and I know we're not getting along." It was obvious that Stewart didn't want any more part of Touhy either. Touhy had made up his mind that he was going to testify at the new trial, and he knew that Stewart was dead set against that. One of the firm principles of criminal jurisprudence is that a defendant must have a lawyer of his own choice. He cannot be required to go on trial with a lawyer he does not want. There have been hundreds of court decisions that have affirmed that proposition.

When Touhy's wife, Clara, visited him he gave her the names of two Chicago attorneys and Thomas McMeekin, the St. Paul lawyer who had been with the defense of the three defendants during the Hamm fiasco. Stevens, Kator and Touhy all agreed that would be a good move. The three lawyers came to the jail—but they couldn't get in. The warden had orders from the criminal court that Touhy could be visited only by the lawyer listed as his representative: Stewart. That was final.

When Stewart went to Judge Feinberg and tried to pull out of the case, the judge refused. Feinberg also threatened to put Stewart in jail unless he continued to represent them. Stewart was ordered to be ready for the retrial on February 13, only eleven days after the first jury had been discharged. Stewart also asked for a change of venue and for a transfer to another judge. Feinberg refused.

He also ignored Touhy's demand for a new lawyer. Stewart, disgusted, decided he wouldn't show up in court. That didn't work either. Judge

Feinberg had his personal bailiff deliver a letter by hand to Stewart telling him to handle the defense or else. No matter, the trial started on February 13, 1934, as scheduled. The lies against the three men at the second trial were astronomical. Witnesses, including Factor, changed their stories at will. Judge Feinberg didn't question the obvious perjury. And Factor and Gilbert had the biggest liar of all stashed away for round two. Touhy and crew got some bad news at the beginning of the trial. Father Weber sent word to them that he would be unable to testify. His superiors had told him that he would be shipped off to a monastery if he attempted to speak up for them again.

Jake the Barber went to the witness stand and told the same, now somewhat frayed at the edges, story of how he said he was kidnapped from the Dells. When he reached the proper time in his testimony again, Touhy expected the bailiffs to bring out the diagram of the Glenview house basement. It didn't happen. In fact, the house vanished from Jake's second trial testimony. Crowley didn't bring it up, and Factor didn't mention it once on direct examination.

He never mentioned the train whistles, nothing about the stairs or how many steps there were, nothing about the shrubbery near the door and nothing about the location of the bathroom, which he'd talked about in the first trial. When Jake came to the part about having identified Touhy behind the blanket, he hedged cagily.

He now indicated that his blindfold hadn't been too tight, after all—some light came through to his eyes. And it now appeared he may not have seen Touhy immediately after the bandage was removed from his eyes. On cross-examination, Stewart asked him if he hadn't positively identified the Glenview basement at the first trial. "Yes," Factor replied blandly. On the matter of identifying Touhy, he insisted that he was telling the same tale about the lifting of the blindfold that he had told at the first trial.

Judge Feinberg listened and didn't so much as reprimand him. Under a screwball Illinois law, since changed, Jake was practically immune from conviction for perjury, no matter what he said. The law said that a witness could testify at one time and later tell an opposite completely contradictory story under oath. Unless the state could prove which time he lied—and that often was impossible—he couldn't be convicted.

Touhy warned his co-defendants to be aware and watch out for unreliable witnesses surfacing like what happened in the Hamm trial in St Paul. Factor and Gilbert came through as expected. It happened when the trial was well underway.

But first, a little background is necessary. On November 15, 1933, a mail truck had been robbed of $105,000 in Charlotte, North Carolina. Blamed for the job—and guilty as bank cashiers with credit ratings in a gambling house—were Isaac "Ike" Costner, a Tennessee mountain whiskey moonshiner, and Basil "The Owl" Banghart. They were mentioned at the first trial as Larry Green or Larry the Aviator. Ice Wagon Conners probably was in on the Charlotte deal, too, but somebody tied him up with bailing wire, shot him full of holes like swiss cheese and deposited him in a muddy ditch outside Chicago. He hoped to sit down for a quiet talk with Ice Wagon. He thought he knew who had him set him up. Anyway, as the brutal February weather hit Chicago, Banghart and Costner got themselves arrested in Baltimore.

They were practically asking for it by boozing with women in their Baltimore apartment. The neighbors complained, the police moved in and the place was sprinkled like confetti with bank wrappers from the stolen money. Banghart and Costner had been stupid, as are all thieves. Even the smart ones like Willie Sutton spent most of their lives in prison.

Touhy knew hundreds of them in Statesville, and few of them could make an honest living at anything more intellectual than digging ditches or cleaning out cesspools. Organized gangsters with million-dollar bankrolls, the best lawyers and political power, such as the Capone mobsters, are the only ones who get away with crime consistently. And even they get nailed now and then by the federal government for income tax dodges or deportable offenses.

Upon learning of the arrests in Baltimore, Tubbo Gilbert and Jake the Barber met with Joe Keenan, the special assistant U.S. attorney general

Basil "The Owl" Banghart, robber and thief, 1934. *Courtesy of the* Chicago Daily News.

who had been appointed to bring an end to the scourge of kidnapping in the United States. It must have been a jolly gathering, with reminiscences about the Hamm fiasco in St. Paul. Banghart had no reason for any interest in turning state's evidence against Stevens, Kator or Touhy.

He was charged with robbery more times than most people go to the grocery store during a lifetime. He had escaped from the county jail at South Bend, Indiana, after throwing pepper in a turnkey's eyes, and he had beaten the wall of the federal pen at Atlanta, Georgia. No matter what he said or did, they were going to throw the key away on Banghart. Costner, on the other hand, was vulnerable to a proposition from Factor. Only the North Carolina postal truck thing and a moonshine rap were hanging over Ike.

He might be able to squeak by with only a few years behind bars if he made a deal. Jake the Barber and Gilbert spent two days with Banghart and Costner in Baltimore. Keenan got into the spirit of the thing. He allowed Tubbo to take Costner and Banghart back to Chicago rather than send them to North Carolina for the postal truck robbery. It was highly unusual for the government to relinquish custody of prisoners to a state when a federal conviction was a cinch. Evidence later developed that Ike Costner was promised that he would be let off with five years for the robbery and freed of prosecution in the Factor case if he would testify against Stevens, Kator, Banghart and Touhy.

It was a questionable deal, but anything went to nail a kidnapper in those times. After their meeting with the prisoners in Baltimore, Factor and Gilbert rode back by train with Costner and Banghart to Chicago. Tubbo boasted of that ride in an interview with the late Edgar Brown, a famous Chicago writer and war correspondent. Gilbert said in the interview that he sat on the train most of the time with Banghart. Jake the Barber concentrated on Costner. How would you expect a guy smart enough to swindle $7 million out of British investors to make out against a Tennessee moonshiner? Factor could be expected to win, of course. And apparently he did.

On the day that Factor and Gilbert brought the two witnesses back from Baltimore, or the day after, Touhy was walking in the corridor leading from Judge Feinberg's courtroom to the prisoners' elevator during a recess. Touhy spotted Dan Gilbert and a man he had never seen before. He thought that just maybe the guy might be another fake finger, so to be safe, he hid his face behind his coat collar. Touhy overheard Gilbert say, "The guy in the light suit—that's Touhy." He found out later

that this was Ike Costner. When Touhy got back to his cell, he got out of his light suit and put on a dark-blue one. Jake Factor took the witnesses back by train to Chicago.

25
IKE COSTNER'S PERJURY

When Touhy got back to court, Costner was the first witness. Touhy didn't know what the stranger was going to say, but Touhy was glad he'd changed clothes. After some preliminary questions, Prosecutor Crowley asked Ike if he could identify Roger Touhy anywhere in the courtroom. Costner stared wildly around the room. He looked at spectators, the bailiffs, the jurors and even the judge.

He was searching apparently for a man in a light suit. Touhy felt like laughing but managed to keep a straight face. Costner seemed to be bewildered. Suddenly, his lawyer tapped Touhy on the shoulder and said, "Stand up, Roger." There was nothing he could do but obey. Touhy stood, and Costner pointed his finger at him, blue suit and all. Right then and there, Touhy figured that Stevens and Kator were going be sent to jail for life.

Touhy would never get over being bitter about Stewart making him stand up and be a clay pigeon for Costner to identify him. It probably wouldn't have happened if Stewart and Touhy had been on speaking terms. But they weren't. Touhy admitted that he didn't tell Stewart about the fingering and why he switched his light suit to a dark-blue suit. Stewart said that he regarded it as psychologically important with the jury to have a defendant admit his identity at once, rather than wait to be pointed out. Touhy didn't like that reason because he didn't believe Costner could have identified him without his lawyer's help.

Ike testified that he had known Banghart for four or five years and that Basil the Owl had visited him in Knoxville, Tennessee, sometime in mid-

June. Costner also said that Touhy's brother Tommy, Kator, Ice Wagon Conners, Willie Sharkey and a few others also visited him. The rules of evidence provide that a witness at a trial may not repeat any conversations that took place outside the presence of the defendants.

The prosecution didn't dare put Stevens and Touhy in Tennessee because they were supposed to be in St. Paul, kidnapping William Hamm, at the time.

Therefore, Costner couldn't come right out and say that Kator, Banghart and the others had recruited him to help snatch Jake the Barber. Crowley, by skillful questioning, got the idea across to the jury, however. Costner said that he drove to the Chicago area alone between June 25 and 28, went to Park Ridge and stayed at the Owl's apartment. Costner indicated he knew why he was in Illinois and what was going to be done. Why a tough Chicago-area gang should take the trouble to go all the way to Tennessee to persuade a hillbilly to join in kidnapping Factor was material for a comedy skit. Costner was a moonshiner and a chicken thief; he didn't have a hotshot reputation to be invited to get involved in a kidnapping.

The biggest job he did was the Charlotte mail job. He admitted that he was a stranger to all of the purported kidnappers, except Banghart. Why would they want him or trust him? His story was ridiculous. Ike said that he was introduced to Stevens and Touhy in Jim Wagner's bar. He said that he slept at various houses, but he couldn't identify the Glenview house, which had been so important for the prosecution in the first trial. At about eleven o'clock on the night of June 30, he was sleeping in one of the houses and somebody, maybe Ice Conners, woke him up.

He testified that he saw Stevens, Kator, Banghart and Touhy and that Banghart said, "We are going to grab Factor." Ike said that he got dressed and joined the group. Touhy was driving his car, he said. There was a wait of an hour or two by the kidnappers in several cars near the Dells, according to Ike.

He said that a man, presumed to be Silvers, twice came out of the Dells and talked to the kidnappers, describing Factor's Duesenberg and his clothing. Silvers was the character who purportedly ended up in the Atlantic Ocean in a concrete coffin.

Costner's story of the alleged kidnapping was about the same as Factor's. Ike said that he carried a shotgun and he saw machine guns and other weapons. He testified that Factor was taken in his car and Roger Touhy was in the backseat with Jake. He drove following directions from Touhy and stopped at a house, which Factor was taken into. Costner said he didn't know

the location of the house. He couldn't recognize it again because of the darkness, and he didn't go into the house that night. He spoke in a low voice, with a deep southern accent. The jury, which consisted of twelve Yankees, had trouble understanding him.

He tried to be a believable, straightforward witness, but he had handicaps. His biggest stumbling block was his ignorance of Cook County geography. He didn't know the names or locations of towns, railroads, landmarks or houses. When such points came up, he said in a whining voice, over and over again, "Ah cain't remember."

As a liar, Ike was lacking in Jake's finesse. Throughout his testimony, Costner tried to set himself up as a kidnaper described by Jake as the "good man" or the "coffee man." It was obvious at this point of Ike's story that somebody was lying. Factor had testified that the good kidnaper sat with him all of that first night, comforted him with conversation and brought him toast and coffee in the morning.

But Ike said under oath that he hadn't been with Jake at all that night. Costner said, instead, that he stayed at another house, the location of which he couldn't remember, with people whose names he couldn't recall. He went back to the purported kidnap house the following night and drove in a motorcade that took Jake to a farmhouse about fifty or sixty miles away. He didn't remember where the new place was. Maybe he might recognize it if he saw it again. Ike said that he stayed in the place during all the time Jake the Barber reputedly was held captive there, or for eleven days.

He said he went out on the lawn now and then but he couldn't recall anything about the surroundings. He said that he didn't even know what color the house was painted. "Ah cain't remember," he said. The witness's tricky memory, or lack of rehearsal, tripped him on a number of points. Jake said that he saw Touhy and another man, partly hidden by a blanket, when he wrote the ransom note.

Ike testified that there was a blanket in the room over a window. It seemed apparent that he was not aware of the significance of the questions about the blanket. Jake had sworn that there was a lamp on the table on which he wrote the note. Ike said that the light came from a ceiling fixture. Also, Costner said that he never saw Factor look up at Touhy or anybody else while writing the note.

Those facts, taken separately, may seem insignificant, but there were hundreds of other contradicted prosecution points throughout the trial. Added up, they became important in a pattern of perjury. When asked about Factor's physical condition, Ike said that it had been bad, very bad.

He testified that Jake had been very sick, very weak, unable to eat heartily, very nervous and "shaking like a leaf" as he reclined on a bed in the second house. It was tear-jerking stuff, but it didn't fit well with Officer Gerard's description of Jake when he showed up at LaGrange. On the night of July 12, Costner said he soaked the adhesive away from Jake's face with alcohol, put a new blindfold on him and drove the car that took the victim to LaGrange. Stevens and Banghart were with him, Ike testified. It was obvious that Basil the Owl was being dirtied up wherever possible. He had refused to turn state's evidence. He was a bad man. Costner, conversely, was being presented at the "good kidnapper," an approach that might make him more acceptable to the jury. It had audience appeal.

On the day after delivering Jake the Barber to freedom, Ike said he went to Banghart's Park Ridge apartment, and Banghart gave him $2,400. "I understood the money was my share of the ransom," Costner stated, adding that he carried the cash, in $20 bills, for a week and then put it in a bank. The truth was that Ike hadn't been within several hundred miles of Chicago on the date Factor claimed to have been kidnapped.

Costner was in Tennessee during all that period. Costner continued in his testimony with the stupid story of making telephone calls to Jake, as "the coffee man," to collect another $50,000.

As the defendants went back to jail in their handcuffs and chains after hearing Costner's lies, Stevens had a comment, "Magnificent." Touhy asked him what the hell he was talking about, and he replied: "A magnificent frame up, of course."

Touhy instructed Stewart to send some investigators down to Tennessee and check up on Costner. It was a fine idea, but there wasn't time. Ike had been a surprise witness, and there had been no opportunity for the defense to investigate him in advance. It would take days, or weeks, to run down Costner's story in Tennessee. By that time, the verdict would be in, and it would be a bad one, Touhy felt certain.

Stewart jumped at Costner on cross-examination. Stewart showed that Ike was a worthless bum, a faker, a thief, a mail robber and a lying scum stool pigeon. But his efforts didn't accomplish a hell of a lot. The prosecution had already conceded that Ike was a no account scoundrel. Costner insisted that this time, just this once, he was telling the honest-to-God truth.

Stewart demanded to know whether Costner had made a deal with Factor in Baltimore and on the train, if he didn't hope to get a pass in North Carolina in exchange for lying about Stevens, Kator, Banghart, Touhy and others. Costner sure hoped he would get a break.

On his story of taking part in the fake kidnapping, Ike stumbled a few times, but he never fell down completely. His "Ah can't remember" got him out of many a tricky spot, and he didn't contradict himself too badly. Stewart couldn't break him. Touhy snuck a look at the jurors now and then, and he sensed that they were believing Ike. Maybe they thought his story was too fantastic for anybody to have made up. As Costner left the witness stand, Touhy recalled a favorite saying of his father: "The rabbit turned around and shot the hunter." Ike had won. He had become a powerful witness.

PERJURY CONTINUES WITH BUCK HENRICHSEN

Buck Henrichsen repeated his fabrications of bringing Silvers and Silversmith to see Touhy at his request while Factor was away. But, at the second trial, he added that he went along on the collection of the $70,000 ransom money. He was in a car with Willie Sharkey and Jimmy Tribbles when the payoff was made on the highway, Henrichsen said. They took the money in a suitcase to the Glenview house, Buck said, and there he saw Stevens, Kator, Banghart, Conners and Porky Dillon. Stewart got Buck to concede that he hadn't mentioned the ransom collection trip at the first trial. "I was trying to protect myself," he said.

Jake's testimony was only about one-fourth as long as at the original prosecution. The big gun at the second go-around had been the moonshiner, not the swindler. The absence of Father Weber from the second trial was a big loss to Touhy and his co-defendants. He wrote to Touhy's wife, Clara, that he was praying for them. But the lies of Factor, Costner, Henrichsen and others were getting through to the jurors better than the Hail Marys of the good priest. Sin was winning again.

Policeman Gerard came back and repeated his testimony that the bearded Factor had looked well and smelled not badly at the LaGrange Police station. Emily Ivins returned, too, and so did the other faithful. It wasn't enough, and Touhy told Stevens and Kator that they were going to be convicted and probably put in the electric chair, unless they did something.

Touhy demanded that he be allowed to testify. Stevens and Kator wanted to take the stand as well, since it was their only chance. Touhy's lawyer

haggled with them. He wouldn't gamble on Crowley's cross-examination of Touhy's co-defendants with their past records in crime. Crowley would tear them apart, he said. And if he called Touhy as a witness, he would have to call Stevens and Kator or leave them sitting as ducks alone, he said. It didn't make sense to Touhy. Costner had identified all three of them positively as his accomplices in the kidnapping.

Were they such gutless wonders that they wouldn't get on the stand and call him a liar? Factor's testimony had been bad enough, but Costner's was damning. Touhy told Stewart that he was going to stand up and demand of the judge that he be heard. "You can walk out of the court if you want to," Touhy said. "I don't give a damn what you do." Touhy told Stewart, "I didn't want you at the start of the trial and I don't want you now." Stewart stalled a while, then he had a brainstorm. He would call Basil "The Owl" Banghart as a witness.

BASIL "THE OWL" BANGHART TESTIFIES

Touhy thought that was really idiotic. Banghart was, in a sense, as much a defendant in the Factor case as were Stevens, Kator and Touhy. Even though he hadn't been indicted, he had been accused by both Jake and Ike. Banghart had a worse and longer criminal record than either Stevens or Kator. If the Owl had the courage to testify for the defense, what about Touhy and company? Wouldn't the jury regard their silence as a sure sign of guilt? What were they, 100 percent cowards? Stewart explained that he had talked to Banghart and promised them that the Owl's testimony would wreck Costner as a witness.

After talking it over, they agreed to go along with the plan, since Stewart was a lawyer, and they didn't know shit from Shinola. Banghart went to the witness box and swore to tell truth. With his widow's peak hairline, his bony nose and his slowly blinking eyes beneath highly arched brows, his resemblance to an owl was amazing.

His manner was assured, his answers glib, his expression serious. He was, of course, an experienced witness. He testified that he had known Costner for about six years and that Ike showed up at his Park Ridge home on July 19—by coincidence the same day that Touhy was jailed at Elkhorn—and the Owl denied that he had any part in kidnapping Jake the Barber or in collecting $70,000 ransom. After that, Stewart, with a triumphant expression, turned Banghart over to the prosecution for examination. Total confusion followed. If Touhy and company had a chance of a snowflake in hell before, Banghart killed it. It wasn't his fault though.

He was trying to help them, but he wasn't equal to it. Crowley got him to admit that he had given the State Attorney's Office a statement saying he didn't know Kator, Stevens or Touhy. Banghart now reversed himself and said he knew all three of them. He thus was established as a liar at the beginning of his testimony.

Part of Basil's testimony was almost comical, as Touhy read over the transcript years later. Crowley brought out that Banghart hadn't worked for a living in 1932, '33 or '34. The Owl said with a trace of pride that he had a steady job in 1931, however.

> *Crowley: Where did you work in 1931?*
> *A. Banghart: In the cotton duck mill in the U.S. Penitentiary at Atlanta, Georgia.*

The Owl said that he "left the prison without permission," or escaped, and was at large for more than eight months. Crowley brought out that Banghart currently also was wanted for breaking jail after blinding a guard with pepper in South Bend, Indiana. Stewart asked Banghart to give his current occupation, and he got a silly answer. "I'm a fugitive," the witness replied solemnly.

> *Q. Fugitive from where?*
> *A. From justice.*
> *Q. From what kind of justice?*
> *A. The courts of Indiana, South Bend.*
> *Q. They wanted you for what?*
> *A. Automobile banditry.*
> *Q. Anything else?*
> *A. No—well, you might say breaking jail.*
> *Q. At the time you broke out of jail, what did you do? Did you have a machine gun when you broke jail?*
> *A. Yes*
> *Q. Did it go off?*
> *A. Yes.*
> *Q. Did anyone get hurt?*
> *A. An officer.*

"Too bad," said Crowley, glancing at the jury. He now had set up the witness as a prison escapee and a desperado who shot down a law

enforcement officer. Basil wasn't doing well. Crowley tried to get him to confess to the $105,000 North Carolina mail heist. Banghart dodged the issue, saying it had no connection to the Factor case. The dialogue got ludicrous again when Crowley asked him if he knew Ludwig "Dutch" Schmidt, later convicted for the mail robbery. Banghart said he did, having been in stir with Schmidt.

> *Q. You were down in Charlotte with him, weren't you?*
> *A. No.*
> *Q. [Incredulously] What?*
> *A. That has got nothing to do with this [case].*
> *Q. You mean Charlotte has not?*
> *A. Yes.*
> *Judge Feinberg [alertly]: Are you talking about a girl or a town?*
> *Crowley: Charlotte, South Carolina.*
> *Stewart: North Carolina.*
> *Crowley: I just got the states mixed up.*

Then the Owl told the story that Stewart had said would wreck Costner. What a boomerang that was.

Banghart said that he had met Touhy about a dozen times and believed Touhy was with him in Wagner's place on the night of June 30. That was a lie, and it hurt Touhy's case. Touhy said that he hadn't known the Owl from a truckload of watermelons. After the lie about knowing Touhy, Banghart gave testimony that since has been shown to be the absolute truth, although it's doubtful that the jury believed him.

The Owl said that Costner came to him with a proposition for getting some money from Jake the Barber. The newspapers had carried stories quoting Jake as saying that he had agreed to pay an additional $50,000. Banghart testified that he told Costner the deal looked too full of danger, but Ike begged him for a week. He said that the Tennessean finally told him, "Now this fella Factor is willing to pay off and there won't be any trouble at all. Banghart listened to Costner, who asked him if he would be convinced if he had had talked to him face to face? Factor and Costner already had discussed the deal, apparently.

On August 9, the Owl continued, he and Costner met Factor on Twelfth Street in the Chicago suburb of Maywood. He was introduced to Jake by Ike, and Jake said his kidnapping story was doubted by certain federal people and by lawyers for the British government, Banghart recalled. Jake

said that he was willing to pay $50,000 to make the snatch look completely legitimate, according to Banghart.

The proposition would seem reasonable, of course, in that $50,000 would be pennies as against Factor's $7 million British swindle and nothing as against the prospect of many years in prison if the kidnap hoax collapsed.

> *Q. What else was said out there* [in Maywood]?
>
> *A. Well, he* [Factor] *said there was a lot of fellows he could get for a lot less money, but he couldn't depend on them, and he explained to Banghart what he wanted done.*
>
> *Q. What else did he want done?*
>
> *A. He wanted us to call him and build up a story. He said the wire would be tapped and recorded, he had a couple of friends to deliver this money to us, that would not be armed.*
>
> *Q. What else was said?*
>
> *A. I objected, I said: "Well, I don't want to…get shot in the head," and I said, "I don't want to harm any of those fellows that were arrested with Touhy. You know and I know that they did not kidnap you."*

At the time of this conversation in Maywood, Stevens, McFadden and Touhy were under arrest in Milwaukee, charged with the Hamm kidnapping. Banghart continued with his story of the conference with Jake Factor: "Well, I repeated I wouldn't do it if it was going to harm these men that had been arrested and he said: 'Why, I never will identify anybody.' I told him: 'You know, I don't know if you were ever kidnapped or if you weren't,' and he didn't want to talk about it at all. He said, 'That has nothing to do with our transaction.'"

Banghart said he assumed the $50,000 would be delivered by law enforcement officers, presumably by government men.

> *Q.* [Crowley] *And you, a fugitive from justice, were going to accept money from government men?*
>
> *A. Yes.*
>
> *Q. Go ahead.*
>
> *A. But he assured me that there would be no guns, and there wouldn't be any shooting. Of course, there would be a little chase to make it look real.*
>
> *Q. It was going to be an act?*
>
> *A. That's it.*

On the street in Maywood, Banghart testified, Jake the Barber slipped a roll of $5,000 cash to Costner as a down payment. The remaining $45,000 was to be split equally between himself, Costner and Ice Wagon Conners, the Owl said. He told of joining with Costner in making telephone calls to Jake. He knew that law enforcement officials were taping the calls, Banghart said. It was part of the act.

Q. So that you were fooling Captain Gilbert and all the rest of us. This was all in fun?

A. I think Mr. Factor was the one who was fooling him [Captain Gilbert].

Crowley said that he was curious as to why Factor selected Banghart to be one of the persons to take part in the $50,000 ransom collection, and the Owl gave a reasonable answer: "Well, the reason he said [in Maywood] that he preferred me is that Costner had told him that I was a fugitive."

Touhy's confederate in the escape, Basil Banghart. Wanted poster October 9, 1942. (Photo courtesy of the F.B.I.)

A wanted poster with the fingerprints and description of Basil "The Owl" Banghart, Touhy's confederate in the escape from Stateville. *Courtesy of the FBI and CPD.*

That made sense. Banghart, a wanted jail breaker, was in no position to squeal on Factor. Factor could put a hammerlock on Basil anytime he wanted to apply it. It was a criminal's way of taking out insurance against a double cross.

The Owl said that he and Ice Wagon Conners tried to make the collection on August 15, after Costner had gone to New York. The Owl didn't get the money in the fake parcel, he said, and he didn't know whether Conners managed to retrieve it.

Touhy watched the jurors while Banghart was testifying. All of them smiled, and a few of them laughed aloud. The judge held a handkerchief over his mouth, obviously to conceal laughter. The Owl had done his best—but it was no good. Banghart's testimony was anticlimactic. It seemed to be made up—a last, desperate effort by the defense to make a bum out of Costner. The humor in the situation was unfortunate for Stevens, Kator and Touhy. Touhy had a sinking feeling that the jurors believed they had put a comedian on the stand to amuse them—to sidetrack them from the real issues.

Touhy, Kator and Stevens got the feeling that they were dead in the water. They couldn't beat Factor and Costner. Not with the added burden of Banghart's testimony on their backs. They gave up testifying on their own behalf. It was too late.

They listened to the usual roars of oratory by the lawyers. Crowley called Banghart a liar. Stewart said that Factor, Costner and Henrichsen were liars. It didn't mean a damn thing. The jurors had already made up their minds.

28

TRIAL CLOSING REMARKS AND THE VERDICT

In his closing remarks, Stewart pounded at the fact that law enforcement made no record of the serial numbers or denominations of the ransom bills.

He also talked scornfully about the fact that no statement in writing by Factor was produced at the trial. Such a statement must have been taken. It was police routine in all such cases.

Touhy's theory was that Jake signed a statement saying that he didn't recognize any kidnappers. If so, it would have been powerful defense evidence.

Crowley's final words were a dramatic demand for the death penalty. The jury reached a quick decision. The verdict? Guilty. The sentence? Ninety-nine years in prison for each of them. Some of the people in the audience cheered. Touhy didn't get a look at Tubbo or Jake the Barber, but they must have been smiling.

As the bailiffs led them out of the court into the corridor leading to the bullpen and the county jail elevators, Touhy threw up. Kay Hall, a female reporter for the *Chicago Times*, was near him. He was sorry that he messed up her shoes; he couldn't help it. This ordeal was really a disgrace, some of the audience in the courtroom actually cheered when the verdict was read. Touhy knew that he would continue making appeals and would never give up.

29

ROGER TOUHY GOES TO PRISON

Roger Touhy was taken to prison at the diagnostic depot in Joliet, where he lost his last shreds of dignity. He was stripped of his clothing, given a short haircut and put in delousing. He was placed in maximum security, where the cells are six feet wide, twelve feet long and fourteen feet high.

In most of those small cubicles are caged two or three men. An open toilet bowl, without screen, stands in the corner.

Maximum security requires that every man be in his cell from before dusk until after dawn. In Stateville, that meant at least fourteen hours every day. Fourteen hours with the same man or men. It is a marvel that they don't kill one another.

A man is nobody, a number. Touhy became 8711. After he went over the wall and came back, they added *E*, for escapee, to it. Also, the color of the identification shingle above his cell door was changed from white to red, red for danger.

Touhy didn't mean to complain about Stateville in particular, having no basis for comparison, since he had never been in any other prison. Convicts who'd made the circuit of pens told him that Stateville wasn't a bad place, comparatively.

Many convicts learn to do what is called "easy time" in prison. The day comes, after months or years, when they lose their mental anguish, get rid of their bitter resentments, shrug off the daily indignities. They learn to live placidly behind bars, to make use of the advantages that modern penology offers.

It never happened to him. He never made a good adjustment, even though he tried to obey the rules and did his work as long as he had a job assignment. But the thought nagged him constantly that he was innocent. He had been framed. His souvenirs from the FBI boys—spinal injuries—gave him hell. The prison doctors made X-rays and sent the plates to Chicago to be read by experts.

The word came back that medical science could do nothing for him, but "a warm, dry climate might help the patient's condition." A joke, eh? He had ninety-nine years, stolen years, ahead of him in Stateville.

Because of his physical condition, he was taken off all work details. He listened to radio news broadcasts and read the newspapers, but he didn't have the energy or ambition to go to prison school. He just couldn't focus on anything. There were no more than a dozen inmates that he was friendly with during all of his prison time. There is humor in prison, and he came to appreciate it. Gambling without money is one of the funniest things. One convict will say to another, "I'll bet you sixteen glasses on a prize fight or a ball game."

The loser must drink sixteen brim-full glasses of water within a time limit of, say, twenty minutes. Or the payoff might be touching the toes with the fingers one hundred times without bending the knees. Touhy heard of a pickpocket who paid a bet by using his left hand only in the dining hall for six months. When the guy left the stir, he could pick pockets equally well with either hand, they said.

Nights are the worst time in prison. Cons yell in their sleep. Some of them weep and call out for their mothers. The sense of shame for the present and remorse for the past rides them constantly.

Touhy was trying to make a point that any prison is hell. Stool pigeons are everywhere and sexual abuse festers. Boredom and regimentation are constant. Men go no place in prison; they are herded. Herded at meal times, herded at recreation, herded at work, even herded going to the chapel.

The next time you read of convicts being babied or mollycoddled in prison, don't believe it, at least as far as Illinois is concerned. Torture chambers aren't needed to make penitentiary life a constant punishment. Confinement—the segregation that means you are unfit to associate with your fellow men in the free world—is enough.

Warden Joseph E. Ragen of Stateville was never a buddy of Touhy's. He had no pals among inmates. But he has one idea with which Touhy agreed. Every inmate should be celled alone in prison. Decency demands it.

Soon after, he was outfitted convict style, and the psychologists examined him—"bugged" is the verb used by cons at the diagnostic

center. He kept telling everybody he was innocent, which is what every incoming con says. One of the head shrinkers told him, "Settle down, Touhy. Learn to do your time the easy way, a day at a time. Don't throw your money away on legal appeals."

The chief psychologist asked Touhy if he would take a lie test, and he jumped at the chance. Leonarde Keeler, the co-inventor of the polygraph, came to see him from Chicago and said the test would be made the following Friday. He said that it would be okay if he had an outside observer present, and Touhy choose Tom Reynolds, the labor guy with the movie operators' union.

Full of hope, he wrote to his sister Ethel and arranged for her to bring Reynolds to the diagnostic depot on the designated date. It didn't work out. On the day before the scheduled interview, he was shipped from the depot to Stateville, about ten miles away. He beefed about being beaten out of the chance to show his innocence under the polygraph. One of the polygraph operators told him, "You're too anxious, Touhy."

LIFE IN PRISON

At Stateville, he was confused and bewildered for days. He tried to figure out what the hell had jinxed him. Under Illinois laws, it would be thirty-three years, or a third of his ninety-nine-year term, before he could even ask for a parole. He tried to think out what happened to him and finally hit on a reasonable theory. It turned out to be exactly right.

Jake had gone to the Capone mob for help in faking a kidnapping in order to beat extradition. He was close to Murray Humphreys, Sam Hunt and the others. The syndicate big shots would have no part of actually pulling a kidnap job, not even a hoax. Jake was advised to talk things over with Sam Hunt, Joe Silvers or Louis Silversmith, or all three, who ran the Dells.

Buck Henrichsen formerly had hung out at the Dells. He once was chauffeur for a politician who gambled in the place. Buck was an ideal man to set up the hoax. He had rented houses for the labor bosses and would have no trouble providing hideouts for Factor. Also, he could provide men with guns who would make the kidnapping look legit.

Buck Henrichsen had brought in Sharkey, Stevens, Kator, Tribbles, Conners and some of the other bust outs. They carefully kept the stunt a secret from Touhy, because he would have put a stop to it.

Factor had paid the $70,000 to vanish for twelve days. After appearing with his beard in LaGrange, he told the story of the demand for another $50,000, an ace in the hole if he needed it. When the British Bulldog kept nipping at his heels, he used the $50,000 gimmick to build up his story.

Through Henrichsen, probably Ike Costner and Banghart were engaged to collect the belated payoff. They hadn't been in on the kidnap fake, and if caught, they would be unable to expose the details of the hoax, such as Jake's hiding places. Ike and the Owl were former prison pals of Ice Wagon Conners. They had brought Conners in on the deal, probably without Factor's knowledge. Jake had crossed them up by sending a dummy package of $500 instead of the big payoff.

Touhy couldn't say for sure whether the original conspiracy included a frame up for him. It's possible that he was an added starter for the scam. It must be remembered, however, that within a few hours after Jake the Barber vanished, Gilbert accused the "Touhy gang" of responsibility.

The only loose end left hanging was Ice Wagon Conners, and he had been murdered. Touhy was looking forward to that chat on a cloud with Conners.

The ridiculous spectacle of Touhy's trial at St. Paul for the Hamm snatch had allowed plenty of time for Jake's identifications to be arranged. The testimony of Henrichsen, Eddie Schwabauer and Mrs. Sczech, Schwabauer's mother—all later proven to be liars—was obtained in advance. The Glenview house became an added tidbit to entrap him.

Touhy, Stevens and Kator took the blame. Banghart was thrown into the mix after he refused to cooperate and give false evidence.

All of that theorizing made sense, but Touhy couldn't substantiate it. Stevens and Kator had never admitted a word to him about helping fake the Factor snatch. He couldn't communicate with them after he reached Stateville because Stevens was sent to the old prison in Joliet and Kator to the downstate Menard Penitentiary at Chester.

Attorney Stewart brought Touhy's two sisters to visit him. He said he was filing an appeal with the Illinois Supreme Court. Touhy tried not to be bitter toward him, but he said, "No, you're not, Scott. We're through." He didn't want any part of him.

He made the appeal anyway, based on the fact that Touhy's constitutional rights were violated because he was denied a lawyer of his choice at the second trial, and on other grounds. The appeal was turned down after a brief hearing, and it was the last time that the merits of the case were heard for nearly twenty years. After that, Touhy's petitions invariably were denied without a hearing.

That phrase, "denied without a hearing" was to become poison to Touhy. No court in Illinois would listen to him after the original turn-down. Neither would the U.S. Supreme Court.

31

BASIL "THE OWL" BANGHART GOES TO TRIAL

Banghart went to trial before Judge Walter P. Steffen in Chicago on charges of kidnapping Factor. Costner's sister Ella came up from Tennessee and testified that Ike and the Owl had been in and around Knoxville and Gatlinburg during all of the so-called Factor kidnap period.

She had affidavits from fifteen other Tennessee people saying the same thing, and the defense offered to bring all of them as witnesses. The judge refused to allow a delay in the trial to round up the fifteen. The Owl was found guilty and sentenced to ninety-nine years. Then they took him to Charlotte and tacked on thirty-six years for the North Carolina mail heist. He wound up at Menard with Kator.

Costner got the dirty end of the stick from the federal government, and Touhy didn't feel too sorry for him. A judge at Charlotte socked him with thirty years. Ike screamed in protest that the Department of Justice had promised to get him off with five years in a trade for his testimony in the Factor case. The judge wouldn't listen, and the DOJ, as far as Touhy knew, didn't lift a finger to help Ike.

Dutch Schmidt, another of the Charlotte heisters, got thirty-two years. He and Costner went to the federal pen at Leavenworth, Kansas. Dutch was to become important to Touhy years later.

What about Jake the Barber? Aah, he wound up with a sweet deal. Even after the convictions of Stevens, Kator, Banghart and Touhy, the Cook County authorities claimed they still needed to keep Factor in Illinois. It might be necessary for him to testify against Touhy and Company on appeal, it was explained.

Another incident in Jake's strange life took place in 1940 when he applied in Chicago for a permit as a whiskey distributor. Among the character witnesses to put him on a pedestal as a lovely, honest, patriotic, sweet-smelling citizen was listed Tubbo Gilbert. The hearing commissioner turned Factor down on grounds that he could not be believed under oath.

Ironic, wasn't it? Jake the Barber was too big a liar to be allowed to peddle booze, but he was believable enough to swear four men—Stevens, Kator, Banghart and Touhy—into prison for a total of 396 years.

As the months and years trudged by in Stateville, Touhy became, as many long termers do, a cell house lawyer. He studied law books. He got transcripts of the testimony at his trials. He became a sort of expert on the writ of habeas corpus, one of the most precious rights Americans have, although few understand it.

It is the citizens' protection against being unlawfully detained by police for days of questioning—especially against an illegally convicted defendant being buried in prison for life without recourse. On a writ of habeas corpus, a person in custody can obtain a hearing before a court of law.

That was what he needed, a hearing. On every appeal he made, the answer was the same: denied without a hearing. How could he get justice if no court would listen to him? He was nailed in a box and had no hammer to batter his way out. Thousands of Illinois convicts were in the same fix.

Ella Costner's testimony at the trial of the Owl was terrifically important for Stevens, Kator, Banghart and Touhy. If she and fifteen other witnesses would testify that Costner and Banghart had been in Tennessee from June 30 to July 12, 1933, it meant that Ike Costner, star witness, had lied in the second Factor trial. Touhy's problem was that he couldn't get into court to have such evidence heard.

In 1935, Banghart tried a brand-new escape caper at Menard. He got into a big heavy truck on the prison grounds, aimed it at an iron gate that led to freedom and stepped on the gas. Wham! Bang! Crash!

The truck was ruined when it hit the iron gate. The Owl damn near killed himself. But the gate won. It wasn't even badly dented. They put Basil back together again in the prison hospital and sent him to Stateville. The maximum security at Menard wasn't enough, and as things turned out, it wasn't enough at Stateville either.

They met for the first time in the yard at Stateville. The only time Touhy had seen him before was when he had given that well-meaning but God awful testimony at the second trial in Chicago. Touhy asked him why he had said those things, and he replied, "I understood you guys

needed an alibi. I had never seen you before but I tried to help you. I had nothing to lose."

That was why he testified that he knew Touhy and had seen him on the night of June 30 at Wagner's bar. He had thought the testimony would alibi Touhy for the Jake the Barber snatch. The Owl said that it was true that he and Costner had been together in Tennessee during the time Factor had been growing his beard. He told of going to wrestling matches, celebrating Independence Day and dating ladies from Tennessee while Ike was along.

32
ATTORNEY H. ATKINS WITH NEW EVIDENCE

A round early July, Touhy's wife, Clara, got a long-distance telephone call from a lawyer from Knoxville, Homer Atkins. He told her he wanted to meet her in Washington, D.C. She agreed and brought along Tom and Roger Jr. They stayed at the Ambassador Hotel. Touhy recalled when he and Clara had stayed at the same hotel on a sightseeing trip, and the kids remembered it as well.

They didn't know that their father was in prison and kept asking when they were going to see their father again. They kept asking questions like, "Will he meet us here? Will he take us to see the Capitol, the White House and the Supreme Court?" It really hurt Clara to tell the boys that they wouldn't be seeing their father on this trip.

Attorney Atkins told Clara that he had absolute proof that Ike Costner had been in Tennessee at the time of the alleged kidnapping. Atkins and Clara went to Attorney General Cummings and told him of the new evidence. Cummings told them he would look into the matter, but as far as the record shows, he never did.

Attorney Atkins came to see Touhy in Stateville. "Touhy, you'll be out of here in a few months." The man thought he was telling the truth, and Touhy believed him. That was before he had been completely disillusioned by the "denied without a hearing" responses to his appeals to the courts.

When stories of his appeals showed up in the papers, people called him "Terrible Touhy" or "Black Roger" or referred to him as a notorious gangster. There wasn't a judge who would stick his neck out to do anything for him

under those circumstances. It seems that the collective mind of America had been poisoned against him.

Clara retained a fine Chicago lawyer, Thomas Marshall, in 1936. Marshall was convinced from the start that Touhy was innocent, but they needed to convince another person: a judge. Touhy told Marshall that he thought that it was senseless to go to bat on another appeal until they put a mass of evidence together. That evidence had to be somewhere, so they could build a solid case to prove his innocence.

33

DETECTIVE MORRIE GREEN

A Hero

Marshall agreed, but his caseload was very heavy, and he didn't have time to dig up the needed evidence. He suggested a private detective who once had been a lawyer and secured the approval from prison authorities to have the detective visit him in prison. His name was Morris "Morrie" Green. As things turned out, Green did a great job for Touhy.

At first Touhy got the impression that Green wasn't too impressed with his visit with him. He knew, and so did everyone else, that convicts are always screaming that they were framed and were innocent.

"Okay, Touhy, I suppose you want me to get you out of here the day before yesterday."

Touhy explained that he didn't expect any miracles. All he expected was a thorough investigation. He told Green about Ella Costner's testimony and of the word from the Knoxville lawyer, Homer Atkins.

Touhy felt that if he could convince Green of his innocence, it should be a cinch to persuade a judge. He suggested that he get in touch with Stevens, Kator, Buck Henrichsen, Mrs. Sczech and her son, Eddie Schwabauer.

Green wrote down the information given him, said goodbye and left the visitor's room. Touhy didn't get the impression that Green was too impressed with the clues he was given. But lo and behold, Green came back in two weeks and had an entirely different attitude. He was even smiling. When he sat down at the table across from Roger, he told him that he believed in his innocence. He said that he talked to the people he'd told him to see, and this case was a stinking frame job. Green then said with a big smile, "I have the facts to prove it."

Touhy's blood temperature shot up a few degrees when he heard Green's words. He figured now he had Factor, Gilbert, Courtney, Costner, Henrichsen, Schwabauer, Mrs. Sczech and all of the bastards beat. Touhy had convinced a private detective, who are really the most doubting of all people, that he really was framed.

Morrie Green turned out to not be a cynic. In actuality, he was a considerate, kind, conscientious man with a hatred for injustice. He'd had a few disappointments in his life and understanding for unfortunates like Touhy.

Green told Touhy that he'd interviewed Buck Henrichsen where he tracked him down, working for Billy Skidmore in the junk yard at 2800 South Kedzie. According to Buck's wife, Buck got the job through Tubbo Gilbert and Assistant State Attorney Crowley. They told Henrichsen that he had a choice of being a defendant or eating steaks at the state's expense. They said that if he ever got out of line they would indict him for kidnapping Factor and get up on the stand with Touhy and the others.

Green pushed for more information, and Henrichsen eventually admitted that he and Eddie Schwabauer had been paid off by John Factor to lie on the witness stand.

Green reported that he'd told Henrichsen that they both knew that Touhy was innocent and that Henrichsen ought to do the decent thing by telling the truth. "He [Henrichsen] told Green that he had a wife and three or four kids and that he had a job, that he owed a duty to his wife and family, and he didn't want to antagonize Gilbert."

Green testified the following under interrogation by one of Touhy's lawyers, Frank Ferlic:

> Q. Did he [Buck] at any time tell you about having gone down to the Sycamore jail to see Factor?
>
> A. He said that he used to go there and get money and he would meet him [Factor] on the stairway.
>
> Q. Did he say anything about anyone else going down there with him?
>
> A. Yes, Eddie Schwabauer.
>
> Q. Schwabauer got money too?
>
> A. That, I couldn't say.
>
> Q. Did you ever have any conversation with Henrichsen about his testimony in the Touhy case?
>
> A. He said he had to testify the way he did.
>
> Q. You wanted to get a sworn statement from him, didn't you?

A. That's right. He said he had the choice of being a defendant or testify the way he did and eat steaks. [Buck was referring to his luxury life in the Palmer House and the Oak Park Arms Hotel while in "protective custody" as a prosecution witness.]

Q. Did he [Henrichsen] *tell you who gave him that advice?*

A. Tubbo Gilbert and Wilbert Crowley.

Q. He [Henrichsen] *made it clear, that they were the ones who gave him this advice?*

A. They told him that he would be indicted for the same crime and be a defendant right along…with Roger Touhy and the other fellows.

Tubbo Gilbert and Assistant State's Attorney Wilbert Crowley denied Henrichsen's statements, as quoted by Green. Nevertheless, Green's testimony had a powerful effect on Judge Barnes's decision that Touhy was framed for the crime of kidnapping. The information that Morrie Green learned from Henrichsen was only a small part of the lies told by Schwabauer and Mrs. Sczech. Morrie Green was truly a great investigator, able to get the truth out of the people he questioned.

Both Mrs. Sczech and Schwabauer, upon being questioned by Morrie Green, admitted that they had lied at Touhy's trials. When Green told them that he had proof of Touhy's innocence, they admitted almost right away that they had perjured themselves.

Mrs. Sczech said that within an hour after the fake kidnapping at the Dells, Factor had arrived as a voluntary guest at her Des Plaines home. Two or three other mopes were with him, he wasn't blindfolded and his hands weren't tied. Factor stayed in the house from about 2:00 a.m. until after dark that day, Saturday, July 1, 1933. He was free to come and go and had use of the telephone if he desired. No one restrained him in any way.

Green was 100 percent sure that Factor had never been kidnapped. This new information was turned over to Marshall. Mrs. Sczech and her son were willing to sign sworn statements, but they wanted to get out of Chicago, being nervous for obvious reasons. Attorney Marshall agreed to drive Eddie, his mother and Green to South Bend, Indiana, where he had a friend, also a lawyer and a member of Congress. They made sworn affidavits and signed them.

Eddie Schwabauer said that Henrichsen had called him to Wagner's saloon about 11:00 p.m. on June 30 and told him a rich man was in a jam and wanted to disappear for a while. Could the man hide out at Mrs. Sczech's house for a few days? There would be money in the deal. Eddie

agreed to the deal; Henrichsen didn't mention Factor's name but did say that Buck told him not to say anything to Roger Touhy. She fixed a bed for the stranger (Factor) in a second-floor room. He slept in an unlocked room, without any guard.

Mrs. Sczech went shopping in the morning, picked up a newspaper with a headline saying that Jake had been kidnapped—there was a photograph of the alleged victim on page one. She recognized it, according to her affidavit, immediately returned home and told Buck Henrichsen to get that man out of her house.

It should be emphasized all of this happened in Mrs. Sczech's house in Des Plaines, not in the Glenview house where Jake the Barber had testified to being confined, visiting the toilet, hearing train whistles and being threatened with having his ears clipped. The Glenview house was about five miles from Mrs. Sczech's home in Des Plaines.

Henrichsen came to her place that afternoon. There had been a meeting between him, Factor, Willie Sharkey and Ice Wagon Conners. Mrs. Sczech testified in her affidavit that Henrichsen told her that Factor would leave her house after dark. Eddie said in his affidavit that Henrichsen came back between 8:00 and 9:00 p.m., with Connors. Jake walked out of the house without a blindfold and, seeming unconcerned, got in a car and was driven away, Schwabauer said.

Morris Green testified later in court that Mrs. Sczech gave her affidavit of her own free will but seemed to be apprehensive.

> Q. What was she afraid of?
> A. Bodily harm.
> Q. From whom?
> A. From the syndicate and the State Attorney's Office.
> Q. Did she tell you she was afraid of bodily harm?
> A. Yes, that is why we took the statements out of town.
> Q. What about Ed Schwabauer?
> A. The same goes for him.

Green explained that Mrs. Sczech and her son wanted to be protected until after their affidavits were filed in Washington. That made sense. Few, if any, terrorists have the courage to harm or murder witnesses in U.S. Supreme Court cases.

Morrie tried to take Eddie and his mother to Canada for safety, by way of Detroit. They were turned back at the border because they didn't have

the proper papers or a valid reason to visit Canada. Green drove them back to Chicago.

Morrie Green was able to prove through testimony and evidence that Roger Touhy was innocent and had been framed for the fake kidnapping of Jake the Barber Factor.

Morrie then visited two of Touhy's associates at the Menard prison, Stevens and Kator. They were convicted with Touhy on the fake Factor kidnapping. Morrie learned from them that they had, in fact, been in on the Factor hoax. Buck Henrichsen had brought them into the deal, and they had shared in the $70,000 payoff. Years later, in court, Stevens told Touhy, "We were afraid to let you know. What in the hell good would it have done anyway?"

Stevens and Kator told Green that Buck Henrichsen made arrangements for them to keep Factor company in a house at Bangs Lake in Wauconda, Illinois. Green found the house used in the fake kidnapping and both the owner and the yardman. They both gave sworn testimony that they had seen Factor on the property during the time that he was missing. They also swore that they had seen Factor taking walks around the lake alone on several occasions.

Green also interviewed the comedy team of Harry Geils and Frankie Brown, who had been hired to entertain Factor in the house in Bangs Lake. They gave statements that Factor was not tied up when they saw him. In fact, they had drinks with him.

Green returned to Stateville to inform Touhy of the progress he had made on the fake Factor kidnapping, and Touhy jumped for joy with the news. Touhy contacted his lawyers with Green's evidence and prepared an appeal for the Illinois State Supreme Court. But their appeal was denied without a hearing, as was another appeal placed before the U.S. Supreme Court.

A reporter for a local newspaper, the *Chicago Daily News*, who had worked with Morrie Green in the past had taken up Roger's cause. The reporter even had developed his own information, which he said would make it possible for Touhy to get out of jail before Christmas. Then the reporter was diagnosed with cancer and passed away. Touhy was again depressed. But it wasn't hopeless. Touhy still had a magazine story written by the reporter's colleague, William Gorman, going for him. It was a positive article, and Touhy felt very good about it. Then came the day when Gorman showed Touhy the rejection slips about the article.

With all hope gone, Touhy's world closed in around him. How could Touhy get justice if all of his appeals were denied without a hearing? There

was no way that he could get justice if no court would even listen to him. That is when he decided to escape and went over the wall at Stateville on October 9, 1942, with Gene O'Connor, Basil Banghart, Eddie Darlak, Nelson, McInerney and Stewart.

34

TOUHY AND SIX OTHERS ESCAPE STATEVILLE PRISON

T he inmate who came to him with the idea of escaping was Gene O'Connor, who was serving a life sentence for a May 1932 robbery in which a Chicago policeman had been shot in cold blood. The time for escape seemed right. The war had taken away the younger guards, leaving mostly older men, some coming out of retirement to resume duty. The guards were paid starvation wages. O'Connor had primed the escape by bribing the tower guards with food, including one-hundred-pound sacks of sugar, bags of coffee, quarter sides of beef and slabs of bacon. All of these items could be resold on the outside for big money.

The escape was made possible by getting two handguns, which were left at the base of the prison's flagpole by the brother of another inmate, Eddie Darlak, who was in on the break. A trustee had brought the two guns into the prison by wrapping them in an American flag, which he lowered each evening outside the prison walls.

On the day of the break, October 9, 1942, Touhy was standing at the prison bakery door with a pair of scissors stolen from the tailor shop hidden inside his blue prison-issue shirt. When the prison laundry truck pulled up to the door, Touhy leaped up into the driver's door and told the driver to get out of the truck. Touhy drove to the mechanic shop where the other escapees—O'Connor, McInerney, Darlak, Stewart and Nelson—were waiting.

Touhy jumped out of the truck, and O'Connor handed him a .45 automatic pistol. Touhy rushed into the mechanic shop and began cutting the prison telephone wires with his scissors. A guard named Johnston was

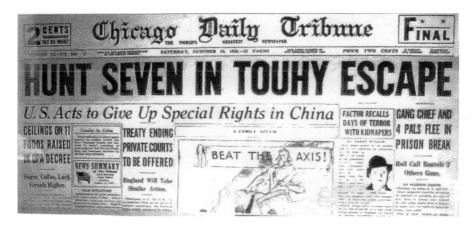

The *Tribune* headline after Touhy and six others escaped from Stateville. *Courtesy of the* Chicago Tribune.

about to club Touhy into submission when Basil Banghart came into the room with a pistol. Johnston dropped the club, and Banghart ordered him to unlock a set of ladders. Another guard named George Cotter came into the room and was overpowered by the escapees.

Placing the guards' white hats on their heads, they pushed Johnston and Cotter outside and forced them to load the ladders on the back of the truck and instructed them to sit on the ladders to keep them from falling off. Roger then shouted at Stewart who was behind the wheel, "OK, lets get out of here," but the truck stalled. They decided to try and jump start the truck. Touhy looked over at about three hundred inmates who were crowded around to watch the excitement. Touhy yelled at the convicts to push the truck, which they did. It worked, and the motor started with a roar.

They drove across the yard to Tower Three in the northwest corner. They put the ladders together at the base of the tower and started climbing. Roger could see one of the guards they had bribed standing to one side of the tower, at the end of the walkway. He noticed that he wasn't holding a gun, but he didn't have far to reach for one. Roger fired a single shot, which shattered the guardhouse window. Flying glass hit the guard in the forehead, knocking him to the floor.

When they were all inside the tower, Darlak took the guards' car keys. Even though it was against prison regulations, a car was parked at the base of the prison wall a few feet from the tower.

Before they left the tower, the convicts took two high-powered rifles and a pistol, as well as ammunition for each weapon. They then very calmly

walked down the tower stairs, got in the guard's car, a Ford sedan, and sped away toward Chicago.

There were reports of the escapees being seen all over the United States, including the Chicago suburbs, during the first week. But after the second week, news about the war in Europe and the Pacific pushed them off the front pages, and for the most part they were forgotten about.

Through Touhy's contacts on the outside, they were able to rent a large apartment in a tenement building in the neighborhood where Roger grew up. They stayed there for two months, until they began to have arguments among themselves due to excessive drinking by McInerney and Nelson.

When they started talking about getting women, Roger told them to forget about it for at least another three months. Nelson didn't like it and threw a punch, which started a brawl. This brought the neighbors banging on the door. The next morning, Touhy moved out into his own place.

Touhy sat around his small apartment for a few days, enjoying the solitude. He contacted his brother Eddie, who provided him with $2,500 cash and a plan to send him to Arizona. He bought a used car but refused to leave Chicago. He spent $200 of the money to get a driver's license, Social Security card and military draft card, which was necessary in 1942. His name was now Robert Jackson, and he was exempt from military service because he worked in a war plant. He passed his time by driving through the forest preserves and going to the movies.

The only other escapee who knew where Touhy lived was Banghart, who asked Roger to come over and visit their apartment. Being bored and lonely, he took him up on the offer on Thanksgiving and decided to move back in with the others again. The next day, they started playing cards and drinking, and another fight broke out between Nelson and Stewart. Nelson moved out and went to Minneapolis, where his mother called the FBI and turned him in. After being questioned, Nelson told the FBI everything he knew about the escapees and where they were hiding out.

35

TOUHY AND OTHER FUGITIVES CAPTURED

Two Killed in Shootout

Within hours, the agents slowly and carefully surrounded the escapees' apartment. J. Edgar Hoover was notified of this development and arrived on the scene to personally supervise the raid. Hoover always felt that Touhy had embarrassed the FBI when he wasn't convicted of the Hamm kidnapping case built by Special Agent Melvin Purvis back in 1933. In Hoover's mind, the capture of Touhy and the others would justify the Bureau's campaign to put him behind bars.

In reality, Touhy and the others didn't break any state or federal laws by escaping from Stateville. There was no law in the state of Illinois against escaping from prison nor would there be one until 1949. As a federal agency, the FBI had no grounds to be involved in the case at all.

The Chicago office of the FBI had made plans on how to enact the raids on the apartment days before Hoover arrived in Chicago. Agents were set up and the building surrounded. Agents had even rented apartments in the buildings at 5114 North Kenmore Avenue and 1254– 56 West Leland Avenue.

When McInerney and O'Connor returned to the apartment on Leland Avenue, agents, with guns drawn, leaped out from behind a door announcing, "Federal officers! Put your hands up!" According to the agents' reports, O'Connor turned and fired his .45 automatic twice. The bullets hit the railing by the stairs. McInerney was never able to reach the .38 pistol he was carrying because the agents shot them at least thirty times.

1254–56 Leland, where O'Connor and McInerney were killed. *Courtesy of the FBI and CPD.*

When Touhy and Banghart returned to their apartment at 5114 North Kenmore Avenue about an hour later, they used the back stairway. Touhy had parked their car a block away just to be cautious. Touhy said that he had an uneasy feeling for some reason he couldn't explain. Suddenly, searchlights were turned on their apartment window, and a loudspeaker called out, "Roger Touhy, the building is surrounded, come out now and you won't be killed." The men argued about what to do, and after ten minutes they decided to surrender. Banghart yelled out the window, "We're coming out!"

They were instructed to come out backward with their hands up. Banghart came out first, then Darlak and Touhy. About twelve agents leaped on them and applied handcuffs. Agents searched the apartment and recovered five pistols, three shotguns, a rifle and over $13,000 in cash, which was handed over to Tubbo Gilbert, still the chief investigator for the State Attorney's Office.

After Banghart and Touhy had been handcuffed, J. Edgar Hoover, accompanied by a dozen agents and numerous newspaper reporters, walked up to Banghart and said, "Well, Banghart, how does it feel to be a trapped rat?" Banghart then smiled and said, "You're J. Edgar Hoover aren't you?"

"Yes," Hoover beamed. "I am." Banghart smiled again and said, "You're a lot fatter in person than you are on the radio."

The prisoners were transported back to Statesville, where each was sent to solitary confinement, where they were given bread and water, with a full meal every third day. After several days, Touhy was taken out of solitary and brought before a judge, who informed him that his sentence was now 199 years, because under a little-known Illinois law, anyone who aids the escape of a state prisoner receives the same sentence as the prisoner they helped escape. The State of Illinois had decided that Touhy should take on Eddie

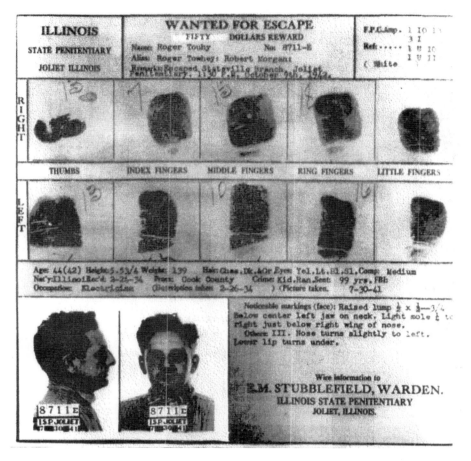

A wanted poster with Touhy's fingerprints and other identifying material. Touhy, Banghart and Darlak surrendered to the FBI. *Courtesy of the FBI.*

Darlak's sentence of 100 years. Roger was the first person to be given this sentence under that law.

Due to the fact that Basil Banghart was becoming a convict legend because of his escapes from prisons, a week after he was returned to Stateville, he was taken out of solitary confinement and transferred to Alcatraz. That was bad news for Banghart, because he could fly a plane and drive a car better and faster than most men, but he never did learn to swim.

Touhy added up 99 plus 199, and the final figure always came out the same: 298 years in prison for him. It would be 99 years and 8 months, or long after he died, before he could even apply for a parole. The good news

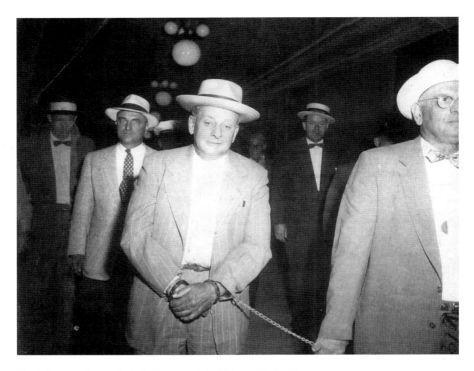

Touhy's appeal was denied. *Courtesy of the* Chicago Daily News.

was he still had Morrie Green's proof of his innocence in the Factor frame up. If he could get the evidence before a reasonable judge, he could get rid of the 99 years. After that, the courts would look favorably on letting him off the hook with the aiding and abetting rap.

Two lawyers, Charles Meghan and Howard Bryant, told Touhy he was on the right track, and they filed twelve petitions for writs of habeas corpus to get him into a court on the Factor conviction. Naturally, the answer was always the same: "Denied without a hearing."

36

ENTER JOHNSTONE AND HOPE AGAIN

T hen one day, he finally got a break. Thanks to attorney Bryant, he had spoken to a Chicago lawyer, Robert B. Johnstone, who became very interested in Touhy's case and visited him in prison. They hit it off right away and discussed Touhy's case for four hours. The forty-two-year-old Johnstone was a practical lawyer, resourceful and daring.

He questioned and questioned him about his story, trying to catch Touhy in a contradiction or a lie. He couldn't, because he was telling the truth. When the interrogation ended, Johnstone said to Touhy, "I might be a damn fool, but I'll take your case if you want me to."

Touhy told him that he would be glad if he gave it a try. Johnstone warned him that it would be a long pull and he should not expect any miracles. He then took his briefcase and left the visitors' room.

Touhy had confidence in the man, feeling that he would do his best for him. When he returned to his cell, he realized that Johnstone had never talked about a fee to handle the case. It was a good feeling to know that Johnstone's first concern wasn't money.

Touhy heard a story that when Johnstone returned to his office, he informed his secretary and associates that from now on he was going to be handling the Roger Touhy case and would have no time to take care of lawsuits, petitions, writs and other documents. He instructed his secretary to refer all that stuff to other lawyers. His associates probably thought he had cracked up. It took him years to build a law practice, but he didn't care that the cases he gave to the other lawyers would have earned him thousands of dollars in fees.

He not only wrecked his career, but he also messed up his health working for Touhy. When his name showed up in the papers in connection with his case, his friends and associates asked him, "Why are you representing that terrible gangster?" He tried for a while to explain that he was trying to prove that Touhy had been framed by the syndicate and Jake Factor but soon gave up.

On his fourth visit to see him at Stateville, they had an argument when he informed Touhy that it was time that he brought his wife and sons back from Florida. Touhy refused and told him that Clara had set up a new life for herself and the boys, Roger and Tommy, who were of college age. "Don't be a dope," Johnstone said. "You're innocent. You have nothing to be ashamed of, and neither has your family. Clara and the boys want to see you. They want to show that they have faith in you. They have that right."

Touhy wouldn't give in, but Johnstone pulled a fast one on him. Touhy was sitting in his cell on April 22, 1948, feeling very depressed. He remembered that it was the twenty-sixth anniversary of his marriage to Clara.

37

THE TOUHY FAMILY REUNION

A convict messenger came to Roger's cell with a pass for him to go to the administration building. This meant he had a visitor. The building was a long walk, which took him through the mess hall and then a canopied sidewalk that smelled of fresh grass. Hundreds of cons, each assigned to a plot for growing flowers, were busy with their spades and trowels. When he reached the visiting room on the inmates' side and looked through the door, his heart jumped a beat when he saw Clara and their two sons, who were looking up and smiling at him.

Johnstone had been right. It had been ten years since he had seen Clara. She said she hoped it was all right. "Mr. Johnstone told us to come back." They talked for an hour. Roger asked his sons how it felt to visit their father in prison. Their answer was, "Mother told us as soon as we were old enough to understand what had happened. She told us that you were innocent. We were never ashamed and prayed for you every day." Touhy felt great as he walked back to his cell. He felt he was a family man again.

The next time Roger saw Johnstone, he was off on another tack: he was determined to get Ike Costner into Touhy's corner. Roger agreed that was a great idea. An ex-con from Leavenworth had hit Statesville a few weeks before and was a few cells away from Roger. He brought him a message from Dutch Schmidt, one of Ike's partners in the North Carolina mail robbery. Dutch had sent his best regards and asked him to give him the word if there ever was anything he could do for him.

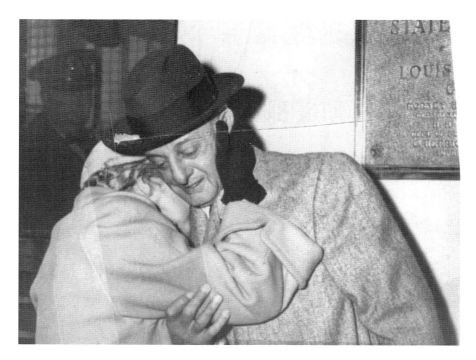

Touhy reunited with his wife. *Courtesy of the* Chicago Herald Examiner.

Touhy told Johnstone that the thing for him to do was go to Leavenworth and see Schmidt first, before approaching Costner. He had a hunch that Dutch would help them persuade Ike to come to come through with the truth. When Johnstone arrived at the Kansas City pen, Dutch told him that he was expecting him and had a talk with Ike. Johnstone wouldn't have any trouble with him. Costner wanted to get a load off his mind and told Johnstone that he had no part in any kidnapping of Factor and he'd lied against Touhy and the others.

Costner gave Johnstone a signed sworn affidavit that he had perjured himself at the second Factor trial. Jake the Barber and Tubbo Gilbert had persuaded him to do it, Ike said. The ground was now solid for a petition for a writ. Touhy's luck held up for him when Judge Barnes agreed to hear it.

JUDGE BARNES'S OPINION

Judge Barnes wore a full beard because he considered shaving a waste of time, and he was regarded as one of the most brilliant men in the history of the American bar. He was stern at times but had a deep well of understanding, courage and sympathy. He had a personal tragedy and loss, as two of his sons had been killed in combat in World War II.

Judge Barnes hated injustice and despised influence peddlers. A former U.S. senator once was interdicted in a case on Judge Barnes's docket. The senator, a politically powerful character, waited for the judge at the doorway to his courtroom, got his attention and said, "Judge, I'd like to have a few words with you about an upcoming case." The judge stared at him angrily and said, "Senator, if you so much as mention the name of the case to me, I will send you to jail for a year. You will go to jail, too, and you will serve every day of the term."

The hearing before Judge Barnes was scheduled for June 1949. Touhy was transported from Stateville to the Cook County jail for the duration.

Touhy had good feelings about the hearing, with Bob Johnstone leading the way. He was very edgy, being so full of the truthful facts of the Touhy case and really outraged by injustice that he seemed ready to explode at any time. Touhy tried to warn him to relax a little, but all that did was really piss him off.

Bob opened the hearing by saying that Roger Touhy was being illegally detained in prison and Touhy had been improperly convicted by perjured testimony with the knowledge of the prosecution in the Jake the Barber

trial. Bob Johnstone said that the conviction on the aiding and abetting rap was unconstitutional, and he added that the judge should order Touhy freed at once.

An assistant Illinois attorney general, Ben Schwartz, made an opposite opening statement. Because he had been convicted in a state court, Touhy must exhaust all state court remedies before going into federal jurisdiction. He contended that he had not used up all his Illinois state appeals and that therefore Judge Barnes had no right to handle his case.

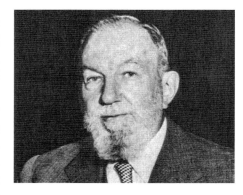

Judge Barnes was an honest judge who believed Touhy was framed. *Courtesy of the FBI.*

Everything was going along fine. Johnstone had been calling primary witnesses when a disaster struck. Johnstone collapsed and was taken to the hospital in a coma. His condition was critical, the doctors said. Judge Barnes continued the case until October 19. Touhy was taken back to Statesville, very depressed. He had never felt worse, thinking he was a jinx to everyone.

When the continuance date arrived on October 19, Johnstone had fully recovered and was ready to proceed with the case. But Schwartz obtained some legal delays. When they finally got before Judge Barnes again, months had passed since Johnstone had called fifty-seven witnesses, both by deposition and in person, over a period of thirty-six days.

Touhy finally had a chance to tell the full true story of the years that were stolen from him for the first time in any court. Morrie Green was there to tell how he had proven Touhy innocent. So were the two police officers Miller and Maloney, who quoted Factor as saying that he couldn't identify Touhy. Testimony came out about the true stories of Stevens, Kator, Banghart and, more importantly, Costner. The Tennessee witnesses were also very important.

Crowley, Courtney and Gilbert also testified, of course, denying that they knew anything about a frame up against Touhy. Then it was Jake the Barber's turn to testify. He had to talk about an Iowa grand jury that had indicted Factor and eleven others for their part in a whiskey swindle that conned a total of $459,000 out of three hundred victims in a twelve-state area. Factor was tried and found guilty in February 1943. Judge John Bell sentenced Factor to ten years at hard labor plus a $10,000 fine.

Factor was released from Sandstone Prison in February 1948. He was sentenced to parole for the remaining four years of his ten-year sentence. He had to admit, however, that he had lied about the Glenview house. And he conceded that the prosecution had known that his testimony was false.

George McSwain, acting agent in charge of the Chicago FBI offices, was also called. Judge Barnes ordered him to produce all FBI records of the case, including a statement by Factor, if any, and he refused. The judge sentenced him to jail for contempt, and the Department of Justice appealed the case to the U.S. Supreme Court.

The high court reversed Judge Barnes, saying in effect that the FBI files had to be kept confidential for the protection of informants. They never did obtain the Factor statement, if there was one.

After hearing all of the evidence Johnstone and Touhy could produce, Judge Barnes took Touhy's under advisement.

August 9, 1954, was the day of decision. Johnstone was standing near Touhy as the guards removed his handcuffs in the hallway of the U.S. Courthouse. "Rog," he said, "I don't think you'll ever be wearing those things again." For all of his efforts to seem confident, Bob was trembling—and so was Touhy.

The members of Touhy's family—Clara, Roger and Tommy—were in court, and all waved at Touhy. The only unhappy person in court was Mr. Schwartz, counsel for the State Attorney's Office.

Judge Barnes seated himself behind his elevated desk. There wasn't a sound in the courtroom—he had a fine sense of timing and dramatics. He expressed his gratitude to the lawyers in the case and explained that his ruling was extraordinarily long, because the case was an involved one. The judge began by saying the court found that John Factor was not kidnapped for ransom or otherwise on June 30 or July 1, 1933, though he was taken as a result of his own connivance.

"The court finds that Roger Touhy did not kidnap John Factor and, in fact, had no part in the alleged kidnapping of John Factor."

Vindication had at last came to Roger Touhy. He had been exonerated; his stolen years were coming to an end at long last. The judge went on to rule that the aiding and abetting conviction was unconstitutional. The 199-year sentence was now gone as well.

When Judge Barnes left the bench, there was a stampede of reporters to get to telephones that were being held for them in the hallway so they could call their offices to report the court had freed Roger Touhy, who had been framed for the alleged Jake the Barber kidnapping in 1934.

Roger Touhy was again in the headlines, but there was nothing negative about him. The stories also carried stinging, bitter words by Judge Barnes against Touhy's prosecution and the witnesses who had perjured themselves against Touhy.

Judge Barnes's opinion of Touhy's case ran about sixty thousand words. It covered every facet of the Factor frame up, including many long and involved legal precedents to back up his decision. The judge used scholarly but piercing language in summing up Jake the Barber. "John Factor has an extraordinarily agile mind. He has been everything from a bootblack, newsboy, barber, salesman bucket-shop operator and a confidence man. As far as morals are concerned, he is completely amoral."

All the witnesses who had dealt with him indicated that Factor was eminently well qualified by character, ingenuity, mental resourcefulness and experience to devise and perpetrate a kidnapping hoax. "Furthermore, he had money, which he was willing to spend. He also had a motive. He was in real trouble, he faced a long prison sentence when he went back to England."

When Judge Barnes was through blistering Factor, he took care of another lying witness for the prosecution at the trial against Touhy: "The court is of the opinion that Isaac Costner was not in Illinois on June 30, 1933 and did not come to Illinois until August, 1933; that aside from making telephone calls to Factor....Costner had nothing to do with the Touhy case until John Factor and Captain Gilbert contacted him in the Baltimore jail...and bribed him with the promise of a five-year sentence for robbery in North Carolina, to testify against Touhy. It is true the government did not keep the promise made to Costner, but that wasn't the point. The promise made by Factor and Gilbert was the payment for his perjury against Touhy."

Judge Barnes's comment on Roger Touhy was not a glowing one. He pointed out that Touhy was in the business of violating the Prohibition law, by making and selling beer and running slot machines, but he did give Touhy an even break: "He had never been convicted of a felony. He was a family man, with a wife and two sons of whom he was very proud. He had a brother Tommy who had a criminal record, and with whom, in the public mind, Roger was sometimes confused."

The judge then went into the motive for railroading Touhy: Captain Gilbert hated Touhy, as much as the Capone mob did, principally because of his success making and selling quality beer and aiding labor unions in their fight against the taking over of their unions by the Capone mob. Judge Barnes reviewed the situation in the State Attorney's Office under Tom Courtney during Touhy's two trials. He stated that Courtney and Crowley

were men of "relatively little experience," while Tubbo Gilbert had a long background as a labor unionist and a police officer.

Regarding the testimony of Mrs. Sczech and Schwabauer, Judge Barnes said, "In the court's opinion, they only told the truth when they felt free of the State Attorney's power, and Factor's money. The court thinks that Mrs. Sczech and Schwabauer told the truth only in the affidavits which they made [at South Bend in 1938]."

Judge Barnes, after reviewing the sworn statements made by Stevens and Kator in 1938, said he believed them. Both Kator and Stevens had sworn that Jake never was under restraint or, in fact, kidnapped, the judge remarked, adding, "Roger Touhy knew nothing about the meeting on the proposed kidnapping of Factor."

The judge pointed out that Gilbert, immediately after the reported kidnapping, charged that the "Touhy gang" was responsible.

"The court is of the opinion that the incident of June 30 and July 1, 1933 was a hoax planned by, and executed under the direction of John Factor in order to avoid extradition to England," Judge Barnes said.

As for who was responsible for Jake the Barber's success in beating his removal to England, the distinguished federal jurist pointed out: "The purpose of the hoax, the keeping of Factor in the United States, was accomplished. The responsibility of State's Attorney Courtney for its accomplishment was admitted by Mr. Courtney, who testified that he went to Washington and talked to President Roosevelt. Factor is in this country today because of that intercession [by Courtney]."

To put it in simple terms, Touhy was not an acceptable person to Tubbo Gilbert, Barnes read. "Touhy and the opposition with whom he was associated with were obstacles in the drive of the politico criminal Capone syndicate to control and dominate the labor unions during the period right after the Factor hoax. The criminal syndicate could not operate without the approval of the prosecutor's office, which at that time was controlled by Courtney and Gilbert. It was obvious that the arrangement between Gilbert and the syndicate was closer than a mere nod and a wink."

Judge Barnes went on to say that "the Department of Justice showed an astounding disregard for Touhy's rights and indulged in practices which can't be condoned."

Barnes also said that the Illinois statute under which Roger was sentenced to an additional 199 years for aiding Eddie Darlak's escape back in 1942 was unconstitutional, and Touhy's sentence under that statute was void as a result.

He ended the hearing by pointing out that Touhy had never been connected to a capital crime or listed with the Chicago Crime Commission. Judge Barnes then excoriated the FBI, the Chicago Police, the Cook County's State Attorney's Office and the syndicate.

Finally, Judge Barnes said in plain terms, "This court further finds that Roger Touhy, should forthwith be discharged from custody." When Roger heard Barnes read these words, he stood bolt upright, trembling, and wept. Swarms of people circled Roger to congratulate him as Johnstone tried to pull him from his seat. Roger Touhy walked from the courtroom a free man, passersby crowded around him and sheriff's deputies, court employees and bailiffs shook his hand and slapped him on the back.

JUDGE BARNES RULING VOIDED

Touhy Returns to Prison

As luck would have it, Chicago was hosting the National Conference of State Justices, which met at the Blackstone Hotel to discuss the encroaching power of the federal courts into its jurisdiction. Judge Barnes's ruling on the Touhy case was condemned by these judges. In their opinion, Barnes—a federal judge—had overstepped his boundaries by hearing the Touhy case. They felt that the case should have remained on a state level. The Illinois State Attorney General's Office agreed and filed a motion to have Roger returned to jail, arguing that Roger never challenged the aiding and abetting conviction in court and therefore accepted its terms. The hearing judge held with the State of Illinois and issued a seizure writ directing the U.S. marshals to arrest Touhy on sight.

Roger heard this news on the radio, called Johnstone and surrendered to federal marshals at 4:00 p.m. His freedom had lasted less than forty-eight hours. Roger felt that fate had again turned on him.

He was transported to the Cook County Jail, and the next morning Roger was returned to Statesville, where he was met by Warden Ragen, who said "Well, you're back again."

Clara Touhy seemed to be in a state of shock over Roger's return to jail. "This is just a bad nightmare."

Roger was still optimistic for an early release. The U.S. Court of Appeals reviewed his case, but the decision was against him. Fate again stabbed him in the back. There wasn't any question about Touhy's innocence of the Factor charges. The 199-year term for the escape was the problem. The

Court of Appeals agreed that Touhy hadn't used up his sources of remedy in the Illinois courts.

In order for Touhy to be set free on a court order, he would have to carry the 199-year conviction all the way through the state courts, probably getting turned down and return to federal jurisdiction.

It would probably take years, not because Judge Barnes was incorrect, but because Roger had to unwind the red tape of the law.

TOUHY APPEALS TO ILLINOIS GOVERNOR AND ILLINOIS PAROLE BOARD

Bob Johnstone and other lawyers filed appeals for him in both state and federal courts. Legal technicalities blocked Touhy at every door to his freedom. Judges, in their zeal to follow the letter of the law, seemed to forget that the evidence showed that Touhy was innocent. His best bet was to appeal to Illinois governor William Stratton and the Illinois Pardon and Parole Board.

The board granted Touhy a hearing in 1957. He was allowed to tell his story and felt that the board members were sympathetic. On the day of the hearing, the room was crowded with reporters, many of whom gave him a V for victory sign. Touhy answered the board's questions and then sat down, thinking it was all over.

When a youngish man stood up in the audience and asked to be heard, Touhy recognized him to be Benjamin S. Adamowski, the current Cook County State's Attorney, who had taken the job of Tom Courtney. Roger had a bad feeling about his appearance.

Adamowski was very brief. He said that he wasn't aware of every minute detail of the Touhy-Factor case, but he had consulted with people who did. He did not believe, he said, that Touhy was guilty of kidnapping Factor. Then he said that he would have no objection to Touhy being released from prison. "In fact," he said, "I would urge it." A great feeling of relief surged through Roger. For the first time, a top law enforcement official had come over to his side.

The board recommended to Governor Stratton that he commute Touhy's sentences. He agreed, cutting the kidnap term from 99 years to 72 years,

making him eligible for parole on that one, since he had served 24 years, or one-third of the sentence. He reduced the 199-year term to three years.

Based on that decision, Touhy would be eligible for release at the latter part of 1959. He would have spent more than a quarter of a century in prison for a crime that never happened.

Roger Touhy stated that he had no bitterness, no enmity toward anyone. Instead, he had the deepest sense of gratitude toward the many people who befriended him.

His hope was to live out the few years he had left in peace and quiet, and freedom, with those he loved and respected.

Perjurers

John "Jake the Barber" (swindler)
Dan "Tubbo" Gilbert (police captain; chief investigator Cook County)
Ike Costner (robber, bootlegger)
Buck Henrichsen (thief, alcoholic)
Ed Schwabauer (thief)
Mrs. Sczech (Schwabauer's mother)
Unnamed Chicago printer (Hamm trial)

MELVIN PURVIS, ROGER TOUHY AND JOHN DILLINGER

One of the most historic and renowned manhunts in America involved the manhunt of John Dillinger by the FBI's Melvin Purvis. While Purvis was in Chicago trying to apprehend Dillinger, he became involved in the Hamm kidnapping investigation, in which Touhy was the prime suspect. Dillinger was shot to death at 10:40 p.m. on July 22, 1934, by federal agents when he left the Biograph Theater on North Lincoln Avenue. The movie that night was *Manhattan Melodrama*, a gangster film starring Clark Gable and William Powell. Dillinger had been set up by Anna Sage, a Romanian prostitute who was having a problem with the U.S. Immigration Service—a warrant for her deportation. It was this letter that spurred Sage's betrayal.

A detective named Martin Zarkovich of the East Chicago police had reliable information on John Dillinger's whereabouts and wanted to meet Purvis as soon as possible. Purvis and Cowley met at Zarkovich in a hotel, in room 712, where Cowley had been staying. Zarkovich did most of the talking. He said he had an informant, a woman he had known for years whose girlfriend was dating Dillinger, and the three were going to a movie on the north side the following night. The girlfriend's name was Polly Hamilton.

The informant was prepared to tell the FBI which theater they would be attending. The FBI could handle it from there; all Zarkovich and his partner wanted was the $15,000 reward. Purvis and Cowley said that they wanted to meet the informant before any deals were made. Zarkovich said no problem; Anna Sage would meet them that night. It was sweltering hot, as Chicago was in the middle of a record-setting heat wave.

John Dillinger, bank robber. *Courtesy of the FBI.*

The meeting was set for 9:30 p.m. at 707 West Fullerton Avenue, across from the children's hospital. They met, and Sage insisted on seeing proof that they were FBI agents. Sage told them she was ready to tell them everything; all she wanted in return was to stay in America. Purvis promised Sage he would do everything he could to help her.

According to Sage, Polly Hamilton was dating Dillinger, and she loved him. They would probably go to the Marbro Theater on West Madison Street tomorrow night, Sunday, July 22. As soon a she knew for certain, she would telephone the FBI. Purvis gave her his private telephone number.

Sage went on to explain that Polly Hamilton had brought Dillinger to her apartment a few weeks ago and introduced him as Jimmy Lawrence. He kept his head down. but she'd recognized his profile as that of John Dillinger.

Early Sunday, Purvis and Cowley met in their office and began telephoning most of their squad, telling them to stay in touch, as something might break. They began setting up their plans for the evening. Purvis and Cowley decided not to put a surveillance crew on Sage's apartment, there being a chance that Dillinger could recognize a surveillance and flee. They notified Hoover of their plans. Hoover told them he wanted Dillinger taken alive if possible.

Sage, Hamilton and Dillinger were at Sage's apartment. Hamilton and Dillinger were playing cards while Sage was preparing dinner—fried chicken, Dillinger's favorite. Sage announced that she didn't have any butter and would get some at the store. Sage got to a pay phone, called Purvis and Cowley and told them everything was going as planned: they would be going to a movie and leave about eight o'clock. The G-men were getting nervous when Sage hadn't called by seven. But Sage called a few minutes later and told them, "He's here," but she didn't know if they were going to the Biograph or the Marbro. She then hung up.

Purvis was startled. No one had mentioned the Biograph—it was on North Lincoln Avenue, a narrow street just around the corner from Sage's apartment. Purvis and Cowley summoned men into their office and had them split up to cover both theaters.

About two dozen agents were filled in on the current plan involving John Dillinger. Detective Martin Zarkovich was introduced and did most of the talking. He mentioned the two women who would be accompanying Dillinger and described their appearances without naming them. The older one was "heavily built," about 160 pounds. She would be wearing a bright-orange skirt. The informant said that Dillinger would be wearing gray slacks, a white shirt and dark glasses. He'd had plastic surgery, dyed his hair black and grown a full mustache.

Purvis was to lead five men at the Biograph Theater. His two best gunmen, Charles Winstead and Clarence Hurt, would assist. Two East Chicago cops, Peter Sopsic and Glen Stretch, would complete the team. Someone asked, "What type of guns should we take?" Purvis replied, "Pistols only."

By 8:15 p.m., people were already filing into the theater. Winstead and Zarkovich were assigned to the Marbro Theater with several other agents. There was no show by 8:25 p.m. Things didn't look good at the Biograph, either. Purvis began to feel that this was another flop mission and they never should have trusted Anna Sage or the East Chicago Police. Then, at 8:36 p.m., Purvis—who

was sitting in his unmarked car—glanced to his side and saw two women and a man walk by on the sidewalk. To his amazement, he realized it was Anna Sage and a girl that had to be Polly Hamilton and John Dillinger.

Agent Brown, who was Purvis's partner, saw them as well. As soon as they passed, Brown got out of the car and called Winstead and Zarkovich, who were covering the Marbro Theater, and told them that Dillinger and the two women had just showed up at the Biograph.

Purvis watched from the car twenty feet away as Dillinger bought his tickets and escorted the two women into the theater. He left the car, bought a ticket of his own at the ticket booth and entered the theater with the crowd. He scanned the seats but couldn't see Dillinger. The theater was jammed. They would have to take Dillinger when he left.

Purvis questioned the girl selling tickets. She said that the movie would let out in two hours and four minutes if he stayed for the entire movie. In about twenty minutes, the agents from the team at the Marbro showed up and positioned themselves at the Biograph. Winstead and Hurt took positions on the south side, the direction Dillinger would take if he were to return to Sage's apartment.

Tension rose as the end of the movie neared. Agents all along the street shifted their weight and kept their eyes down, trying to look inconspicuous. That didn't work. At 10:20 p.m., two unmarked police cars pulled into the alley beside the theater. Several men jumped out, guns in their hands.

"Police!" one of the men yelled. "Put up your hands!" One of the agents identified himself and showed his badge to the police. Others did the same and explained they were on a stakeout. One of the officers asked who they were after, but the agents refused to say. "OK, but apparently your stakeout is not very secretive," one of the officers said, "because we got a call of suspicious men hanging around the theater and they looked like they were going to rob it. You guys may have heated the whole area up!"

One of the cops asked if they needed any help. One of the agents said no and asked the cops to leave. Grudgingly, they got back in their squad cars and drove away. Needless to say, Purvis and Crowley hoped all the activity with the police on the scene with their guns out could have caused some theater patrons some curiosity, but hopefully this did not include Dillinger.

Ten minutes passed: 10:30 p.m. The movie was letting out. Just then, another car drove up in front of the theater, and two men got out. They were responding to the same call the other cops had answered. They were two plainclothes Chicago detectives. They got out of the car and began questioning Agent Campbell across the street. Campbell tried to get them to

leave, but they were still asking questions when at 10:40 p.m., there he was: Dillinger, shuffling out with the crowd, Polly Hamilton holding his left arm, Anna Sage on his right side. Purvis tried to look nonchalant. Dillinger was barely five feet from him. He could have reached out and touched his arm.

Purvis struck a match and lit his cigar, giving the signal. Dillinger stepped to his left and guided the women south, the way they had come, right toward Hurt and Winstead. Both agents saw the signal and recognized Dillinger. Of all of the agents outside of the Biograph that night, only a handful reacted to Purvis's signal. Purvis was unsure what to do, so he struck another match and applied it to the cigar, hoping to get the attention of more agents. Dillinger and the women strode past the doorway where Winstead and Hurt stood. When the trio passed Hurt, he stepped behind them. Agent Hollis was in the gutter was right beside him. Dillinger glanced to his right, at Hollis. Winstead took a step forward, and Dillinger looked straight into Winstead's face. Dillinger appeared to realize he was trapped.

Dillinger appeared to lean into a crouch. At the same time, he slid his hand into his pants pocket, attempting to reach his .38. Winstead pulled his .45, and Hurt and Hollis drew their guns as well.

Dillinger broke from the women and took a couple of steps forward, but he never had a chance. No one yelled "Halt" or "Stop" or identified themselves as FBI agents. Winstead fired his .45 three times, Hurt fired twice and Hollis loosed one bullet. Four bullets struck Dillinger. Two grazed him, a third struck him in the side and a fourth bullet hit Dillinger in the back of the neck, severing his spinal cord and tearing through his brain before exiting through his right eye. Dillinger was dead.

The next morning, Dillinger's death was front-page news around the world, dominating headlines in New York, Moscow, London and Berlin. Much of the coverage focused on Purvis. A common story and photo of Purvis was "He Got His Man." This was Purvis's biggest case in his career. Hoover sent Purvis a letter praising him for his unlimited and never-ending persistence, effective planning and intelligence in terminating the career of John Dillinger.

42

THE HONEYMOON OVER FOR MELVIN PURVIS

When J. Edgar Hoover, the director of the FBI, appointed Melvin Purvis his favorite agent and most dependable man, he was the special agent in charge of the Chicago office. There was no other city like it. Purvis was a soft-spoken gentleman who wore elegant suits. And he was sure that he could handle whatever job came up.

The adventure Purvis had dreamed of was about to begin. He had a new fox terrier puppy, which he put in the passenger seat of his shiny Pierce-Arrow sedan and drove from Birmingham to Chicago. By the end of 1934, Melvin Purvis was arguably the most famous man in America, besides President Roosevelt.

He presided over the FBI's sweep of the great public enemies of the American Depression: John Dillinger, Pretty Boy Floyd, Baby Face Nelson. America finally had its hero in the war on crime, and the face of all the conquering G-men belonged to Melvin Purvis.

With each new capture, each new headline touting Purvis as the scourge of gangsters, one man's resentment grew. J. Edgar Hoover, director of the FBI, was immensely envious of the agent who had been his friend and protégé and vowed that Melvin Purvis would be brought down. A vendetta began that would not end even with Purvis's death.

Hoover trampled Purvis's reputation for more than three decades, questioned his competence and courage and even tried to erase his name from all great arrests performed by the FBI.

When William Hamm Jr., a millionaire brewer of St. Paul, Minnesota, was kidnapped from outside his place of business on June 15, he was released

four days later after $100,000 ransom had been paid. FBI agent Melvin Purvis, who was leading the investigation, accused Roger Touhy, McFadden, Stevens and Sharkey of kidnapping Hamm. Touhy recalled telling Purvis that he had a solid alibi for June 15 and he was innocent, as were McFadden, Stevens and Sharkey. He'd told the agent, "You are making a big mistake in accusing us of the Hamm crime."

Purvis did not answer Touhy, but in a few hours, they were all handcuffed with an escape-proof safety belt around each of their waists. FBI Agent Purvis read them warrants charging them with kidnapping Hamm. There was absolutely no honest evidence against them. Their innocence was to be proved beyond a doubt two years later when the real kidnapers were caught and convicted. Purvis didn't investigate Touhy's alibi at all.

Touhy reports that they were kept in maximum-security cells—no visitors, no consultations with lawyers, no radio broadcasts, no newspapers. Touhy reported that he went into jail in good physical condition, but when he came out, he was twenty-five pounds lighter, three vertebrae in his upper spine were fractured and seven of his teeth had been knocked out.

They questioned him day and night, abused him, beat him up and demanded that he confess to the Hamm kidnapping. He was never allowed to rest more than a half hour. On August 13, a federal grand jury indicted them all for kidnapping.

Purvis, having had very little investigative practice, didn't bother to check their alibis at all. The only thing he had was that Dan "Tubbo" Gilbert, the chief investigator for the State Attorney's Office, told Purvis that the Touhy gang had kidnapped Hamm. Purvis wasn't aware that Gilbert was associated with Al Capone and Jake the Barber the swindler. Purvis said in Chicago that there was an "iron-clad case against them."

The truth of the matter is, if Melvin Purvis had checked their alibis against the time Hamm had been kidnapped, the evidence would have proved that it would have been impossible for them to have kidnapped Hamm. There would have been no reason to have arrested them and charged them with kidnapping, let alone indicting them and putting them on trial. All of this was a waste of time and money. When the jury came back with their verdict of not guilty, Purvis was stunned. It was found out later that the Hamm kidnapping was a Barker-Karpis job.

The possible wrongful prosecution of Touhy and his associates had a tragic consequence. One night during the trial, William Sharkey hanged himself in his cell with his necktie.

J. Edgar Hoover was not happy with Purvis or the outcome to the Hamm fiasco. The Chicago papers called them mad dogs and other nasty names. Hoover knew the case was screwed up from the beginning and blamed Purvis.

Then, of course, there was the case of Dillinger and his girlfriend Billie Frechette, who were set up by an informant, Larry Strong. Billie and Strong agreed to meet in a dingy tavern called the Tumble Inn at 8:00 p.m. on April 9. Billie didn't know that Strong had been questioned by the FBI. When Billie and Strong split up, he—or someone he'd talked to—went to a phone and called Purvis and told him about the meeting that night and that Dillinger would probably be with her. Purvis, who wore shabby clothes for the occasion, went in the front door of the dim, dingy tavern. Strong was at the bar, along with an elderly man and a bartender.

Outside, a dozen agents lurked in the streets. At 8:30 p.m., Dillinger drove down the street and parked at the curb. A woman stepped from the car and entered the Tumble Inn. An agent named Metcalfe saw the car park at the curb, but he couldn't see who was driving due to the gathering darkness. Metcalfe walked past the car and saw Dillinger behind the wheel, a Thompson machine gun in his lap.

Inside, Purvis saw Billie when she walked in. She stepped between him and Larry Strong and said things that Purvis couldn't hear. After a minute, Purvis stepped outside and signaled an agent to come inside, which he did, with a submachine gun underneath his coat. Billie and Strong were arrested and the bar and basement were searched, but there was no sign of Dillinger. Purvis then asked Billie how she got there. Someone said in a car. The agents rushed outside, but for the second time in twenty-four hours, Dillinger was gone. When J. Edgar Hoover heard about this screw-up, he was really pissed off.

CERMAK BECOMES MAYOR OF CHICAGO

Anton Cermak became mayor of Chicago at the age of fifty-six in 1931 by beating Big Bill Thompson at the polls. Cermak was born in Bohemia in 1873, and his family immigrated to America in 1884. They moved to southern Illinois in 1900, where Cermak's father found work as a coal miner. When Anton grew older, he moved to Chicago in a Bohemian community, which he organized community into a powerful voting machine.

Anton learned about the world of ethnic politics early and became a political power in Chicago. At the age of twenty-six, he became a member of the House of Representatives in Springfield, Illinois. He worked himself to a position where the state's bankers paid him bribes. After three terms in Springfield, he had accumulated more than $1 million. By the time he was elected mayor of Chicago, he was worth in excess of $6 million. At the time, in 1931, Chicago was the most powerful political location in the United States.

At the age of fifty-six, Cermak declared himself a candidate for mayor of Chicago. As things turned out, he beat "Big Bill" Thompson by the largest margin ever recorded in a Chicago mayoral election. He gave his word to the citizens of Chicago that he would drive out the gangsters before the World's Fair opened in the summer of 1933. In actuality, all he wanted to do was to dominate the crime-ridden city and get rich from it.

The federal government assisted this plan, which aided Cermak by putting Al Capone in prison on an income tax charge. This left a void in the Chicago Outfit. Cermak knew that Roger Touhy had been battling Capone

Assassin Giuseppe Zangara was arrested for the murder of Chicago mayor Cermak. *Courtesy of the* Chicago Daily News.

about Touhy's area for his beer and gambling stops on the north and west side suburbs of Chicago.

Rumor had it that Cermak didn't really want to rid the city of organized crime. Rather, he wanted to control and dominate it. He needed a leader to take care of business. Allegedly, his choice was Roger Touhy, a bootlegger and gambler. Cermak and Touhy had a meeting in Cermak's office during which Cermak urged Touhy to start a war against the Capone mob. Touhy explained that he'd had a few confrontations with the Capone mob as well as with Frank Nitti, the current boss, but none of them involved a shooting war. Touhy also pointed out that the Capone mob had about five hundred members who could be summoned in a few days.

"No problem" was Cermak's reply. "You can have the entire Chicago Police Department." If that remark is true, Cermak should have had his head examined because he was wacky. As the rumor goes, Touhy allegedly agreed to go along with this plan and get in a shooting war with the syndicate.

Cermak and Touhy both knew that this type of operation would cost a lot of money. Cermak assured Touhy that money would be no problem. There would be enough to support a street war against the mob. Cermak, of course, controlled the Chicago Police Department. As the story goes, he allegedly sent word to his police commanders that they were to cooperate with Roger Touhy in his war against the Chicago syndicate.

Of course, Cermak was not going to come up with his money to support this type of gang war, but he had a plan to get it. Allegedly, he informed some robbers, one of whom was Tommy Touhy and five other masked men, that when they robbed the U.S. Post Office in the loop at about 7:00 a.m. on December 6, 1932, there would be no Chicago police in the area, as they were ordered to patrol other neighborhoods.

According to unreliable information, the robbery took place, and the masked men overpowered a guard and stole $500,000 in cash and securities. The getaway was very easy. Now I wonder if the order to leave the area aroused any suspicion by the shift commander or any other police officers in that area?

There were other robberies of mail trucks as well, allegedly pulled off by the Touhys, armed with machine guns. The robbers got away with close to $600,000 in cash, bonds and jewelry.

In between more robberies allegedly pulled off by the Touhy-Cermak gang, they allegedly committed numerous murders of members of the

syndicate run by Frank Nitti. A few names of the victims are Provenzo, Renelli, Maggio, Liberto, Gambino, Jerfitar, Russell and Barber, to name a few. It appeared that the Cermak-Touhy alliance was working.

Finally, Cermak decided to increase raids on places controlled by the syndicate. He increased gambling raids of handbooks and slot machines, and he confiscated the machines. Then, Cermak had a meeting in his office with his special squad, planning the day's activity with information provided by the Chicago chief of police; Ted Newberry, "the mayor's bag man"; and, allegedly, Roger Touhy. The plan was to raid the mob's most lucrative casinos, which they did. Twelve casinos were closed down. Sixteen Chicago detectives were demoted, reassigned or fired for permitting this type of activity to run openly in their districts. These cops who were bought and paid for hurt the mob badly, leaving them with very few cops on the take.

The next brainstorm by Cermak was to have Frank Nitti killed. The mayor called two members of his special squad to his office: Harry Miller and Henry Lang, both police sergeants. Miller had been fired once from the police force for trafficking narcotics, while Lang had been a bag man for Big Bill Thompson. By "special political appointment," they were both back on the job.

Cermak called both Miller and Lang to his office at 10:00 a.m. Newberry was already there. Newberry handed them a piece of paper with Frank Nitti's name and address on it, and they were then told it was time for Nitti to die. Lang and Miller were assigned to do the job. When Nitti was dead, they would both be given $15,000. Miller and Lang drove to Nitti's office at the LaSalle & Wacker building. They flagged down a passing squad car with a rookie cop named Callahan driving it and told him that they may need his assistance on an arrest they were about to make.

The three entered an elevator and went to room 554, where Nitti had a three-room office. They found Nitti with his bodyguard and several others seated around a desk. Lang ordered them to turn and face the wall with their hands over their heads. When Callahan bent down to search Nitti's ankles, Lang fired five shots into Nitti. The rookie then leaped back as Nitti staggered toward the door. The mobster looked at Lang and asked, "What's this for?' and Lang shot him again. Lang then walked into an adjacent room, alone, and fired a single shot. When he returned, he was shot through the hand.

Nitti was taken to the Bridewell Hospital, where was treated for wounds in the neck, leg and groin. The doctor who operated on Nitti reported that the

gang boss would probably die before the night was over. Strange as it may sound, Nitti lived, but it did shake up the Capone organization. The end result was that the new man in charge was Paul "The Waiter" Ricca, who was a lot more dangerous than Nitti.

Nitti was charged with assault, for attempting to kill Sergeant Lang. Before Nitti went to trial, Cermak went to Miami for a reception that had been planned for President-elect Franklin D. Roosevelt. Cermak had played an important role in getting Franklin D. Roosevelt the Democratic nomination when the convention was held in Chicago.

Nitti's trial was held in April 1933. Officer Callahan testified that Nitti had no gun on him when he'd searched him. Nitti was acquitted of the assault charge. Sergeant Miller testified that Sergeant Lang got $15,000 to kill Nitti. The hit had been ordered by the mayor-elect of Chicago, Anton Cermak. Cermak wanted to push the Capone syndicate out of Chicago. Both Lang and Miller were fired from the Chicago Police Department and both fined $100 on an assault charge.

Ricca's first move was to bring in a replacement for Red Barker, who had been murdered: "Three Fingers" Jack White. White then brought in James "Fur" Sammons, a real nutcase, who did time for kidnapping an eleven-year-old girl. Two months after he was released, he got busted for killing a saloon keeper named Barret. For that deed, he was convicted and sentenced to be hanged. He remained on death row, which reportedly was driving him insane. He managed to escape and committed more robberies before he was recaptured.

Both Jack White and Sammons had been paroled in 1923 by the governor of Illinois, Len Small, after paying a small fortune in bribe money to a guy named Dillon, who was one of Small's bagmen. Dillon had once been arrested for robbery, and a judge sentenced him to state prison for ten years. But Dillon managed to set up a pardon for himself through the same crooked governor, Small. White and Sammons made a great pair of hit men for Ricca.

The first guy to get killed was Mayor Cermak's guy, Teddy Newberry, who had planned the hit on Frank Nitti. Newberry's bullet-riddled body was found on January 7, 1933, outside Chesterton in northern Indiana. As the story goes, Newberry was at a party for Gus Winkler, got drunk and made a remark to Capone's personal physician, Dr. David Omens. Winkler suspected that the doctor told the story to Nitti.

The next two guys to get hit were Pat Barrell, vice president of the teamsters, and his bodyguard Willie Marks. They were killed while on a

vacation fishing in Wisconsin. Marks's luck ran out. He'd survived the St. Valentine's Day Massacre because he was late for work that day. It seems that the two men were knee deep in water, fishing, when the killer caught them and blew their heads off with a shotgun. Reportedly this was James "Fur" Sammons.

TONY CORNERO, JAKE "THE BARBER" FACTOR, NEW YORK MOB AND STARDUST HOTEL AND CASINO

Tony Cornero decided to get into the whiskey-smuggling business with some small boats, bringing high-priced whiskey from Mexico to Los Angeles. He bought a merchant ship, stocked it with over four thousand cases of expensive whiskey and sold the illicit booze to the high-class clubs in Los Angeles. All of his deliveries were under cover of moonlight. When 1931 rolled around and gambling became legal in Nevada, Cornero decided to get into gambling and moved to Las Vegas, where he and his brothers opened one of the first major casinos in southern Nevada, near Boulder City.

Things were going very well at the casino. He was making enough money to invest in some other casinos in Las Vegas. The money began pouring in, and before long, New York's Lucky Luciano, Lansky and Frank Costello sent a message to Cornero: they wanted a cut of his action. Cornero refused to pay them, and the result was that the casino mysteriously burned to the ground. Cornero knew that he could never win this fight, so he sold his interests in Nevada and returned to Los Angeles.

Cornero invested in three large ships and decided to refurbish them into luxury casinos, at the cost of about $300,000. The idea was to anchor the ships three miles off the coast of Santa Monica and shuttle gamblers in motorboats to the floating casinos. The ships had waitresses, waiters, cooks and even an orchestra. The ships could handle in excess of three thousand gamblers who could dance, drink and play games of chance all night long. Cornero's profit exceeded $300,000 a night after expenses.

Suddenly, the honeymoon was over for Cornero. He became the center of a reform movement in Los Angeles County. Earl Warren, the state attorney general, began raiding Cornero's ships. Cornero's lawyers' argument that the ships were operating in international waters did not matter to the California government. Cornero knew he was beaten and closed his offshore operations.

JAKE "THE BARBER" FACTOR BUYS THE STARDUST HOTEL AND CASINO

In August 1942, Jake the Barber and eleven others were indicted by an Iowa grand jury for a whiskey swindle. Three hundred victims were conned out of $459,000 in a twelve-state area. Factor was tried and found guilty on February 3, 1943, and sentenced to ten years at hard labor. He was sent to Sandstone Prison to do his time, released in February 1948 and then paroled for the next four years. In 1955, one year after his last meeting with his parole board, convicted felon Jake "The Barber" Factor announced he had bought the Stardust Hotel and Casino in Las Vegas. He was now the owner of one of the largest casinos in the world.

After a few years, Cornero decided to move back to Las Vegas and fulfill a dream—to build the largest gambling casino-hotel in the country—and called it the Stardust. He had to borrow $6 million from the mob to finance the construction. Cornero had numerous arguments with the New York syndicate over the size of the hotel. He wanted five hundred rooms; Frank Costello and Meyer Lansky were sure Las Vegas would never be able to attract enough gamblers to fill all those rooms.

As opening day grew closer, Cornero began talks with Moe Dalitz, the Godfather of Sin City, about leasing the place to the Dalitz operation. Cornero's terms were steep: a half a million a month. Dalitz was interested, but he knew Cornero was broke and would have to come crawling back to him to make a deal.

As fate would have it, Cornero dropped dead while gambling at the Desert Inn with Moe Dalitz. Cornero had gone there for a last-second meeting

with Dalitz to beg the mob's favorite front man for financing to help him complete construction of the Stardust.

The casino was to open in two weeks, on July 13, 1955, and Cornero didn't have the cash to pay the staff or other expenses. Dalitz and Cornero met for several hours, but nothing was accomplished. Cornero decided to pass some time by gambling at the craps table in the Desert Inn—a big mistake, because he blew $10,000 in a short time. The waitress handed Cornero a tab for $25 for the drinks and food he had. Cornero told her he was a guest of Moe Dalitz, but she didn't give a damn and wanted the money.

Cornero threw a fit and screamed and raved at the waitress. He clutched his chest and fell forward on the dice table. He had suffered a fatal heart attack. At least, that appeared to be the cause of his demise. An autopsy was never performed, and his body was shipped back to Los Angeles for a quick funeral. No one will ever know if he was poisoned.

Chicago mob boss Murray Humphreys decided that Jake the Barber would buy the Stardust Hotel and Casino and be the front man for the Chicago Outfit. Jake knew that he was indebted to the gang forever. It turned out to be a Chicago bonanza.

Humphreys and the Outfit knew that Factor could be trusted as their front man, and he was aware that if he tried any con game on them he would be buried in the desert. It was no surprise to Factor, or the Outfit, that Factor, being a felon, would be unable to get a liquor license, but they gave it a try anyway.

Factor faced the facts and announced that he would lease to the Desert Inn Group. A crime syndicate meeting was held in Beverly Hills in mob lawyer Sidney Korshak's office. Korshak never had a license to practice law in California. His law degree was from DePaul University in Chicago. A master fixer, he obeyed the Chicago Outfit and mobster Murray Humphreys, and his power reached around the world even for mundane tasks. Alan King, a well-known comedian, was coldly informed by a desk clerk in a plush European hotel that there were no rooms available. King went to a lobby phone booth and placed a call to Korshak in Los Angeles. Before he had even hung up, the desk clerk was knocking on the phone booth door, telling King his suite was ready.

Sidney Korshak took care of the meeting with the mobsters: Meyer Lansky, Longy Zwillman and Doc Stacher, who represented New Jersey and New York. Morris Kleinman and Moe Dalitz would lease the casino operation. Dalitz represented the Desert Inn. All concerned agreed that the Desert Inn would pay $100,000 a month to operate the casino part of the

Giancana's house. *Author's collection; courtesy of the CPD.*

Stardust. Jake the Barber's name would still be on the paper as the owner of the building and the hotel operation.

The real owners of the Stardust were Tony Accardo, Paul Ricca, Sam Giancana and, of course, Murray Humphreys. Their representative was Johnny Roselli. Carl Thomas, who was the creator of Las Vegas, estimated that the Chicago Outfit had been skimming $400,000 a month from the Stardust in the early '60s, and that was only from the slot machines. Poker, craps, blackjack, roulette and Keno yielded more.

The Chicago Outfit had never dreamed about making this kind of money, and nobody or anything was going to screw up their operation. Around this time, Roger Touhy had been pardoned.

46
PRESIDENT PARDONS JAKE "THE BARBER" FACTOR

During his brief presidency, John F. Kennedy issued 472 pardons, more than any chief executive before or since. About half of these appear to be questionable, at least. The rules that govern federal pardons are rules, not laws. They can be made, broken or ignored by the president. On November 26, 1962, Attorney General Robert Kennedy did something: he changed the laws that govern presidential pardons. The fact is that presidential pardons have seldom been tampered with since they were written in 1893.

The change that Kennedy made in the rules, only sixteen days before John Factor was pardoned, allowed all pardon requests to go directly to the White House and then to the Justice Department—and not the other way around. An incident involving the FBI and an Outfit guy by the name of Chuck English (a bodyguard for Sam Giancana) happened outside the Armory Lounge. English, who had been drinking, walked over to an FBI observation car parked across from the lounge and made a remark to the agents about the "G" closing in on the organization and nothing could be done about it.

Then he made some bad remarks about the Kennedy administration and pointed out that the attorney general raising money for the Cuba invasion made the Chicago Outfit look like amateurs. CEOs and business executives across the country were talking about the same thing. The attorney general of the United States told businesses he wanted money for the Bay of Pigs program and reminded them they had either pending contracts or criminal cases before the Justice Department.

Jake the Barber Factor also knew about the fund to free the Cubans. In fact, he gave $25,000 to the fund, and when questioned by the press, he explained that James Roosevelt, the problem child of the clan, had approached him about the donation. As a member of Congress, Roosevelt supported Factor's bid for a presidential pardon as well. Rumor has it that Factor had given $1 million to the Joseph P. Kennedy Foundation.

Amazingly, a strange thing happened on December 24, 1962, after Factor's contribution to the Bay of Pigs fund. President John F. Kennedy signed a presidential pardon for John Factor for the mail fraud conviction. As a result, the deportation threat against him was dismissed. Law enforcement members who had so much faith in Robert Kennedy's war on crime were in shock. Jake the Barber's presidential pardon came out of nowhere like a bolt of lightning. It was never made clear if Factor's pardon also killed the investigation of Factor's dealing in the Stardust, but the fact is it was canceled.

Jake was trying to take over control of the National Life Insurance Company of America and was buying up the company's shares at $125 each. He then sold four hundred shares to Murray Humphreys at $20 each. Factor's loss was $105 per share. Humphreys then sold the shares back to Factor for $125 a share, making Humphreys $42,000 richer in one day.

After all these years of fighting extradition back to England, Jake was in his glory, but just to be sure, on July 16, 1963, in Los Angeles, John Factor, the poor nobody from the ghettos of Chicago, raised his hand along with a dozen other recent arrivals and took the oath of citizenship of the United States of America. His only reply was, "I have to be the luckiest man alive."

After a long illness, John "Jake the Barber" Factor died at the age of ninety-one in 1984. His wake was attended by more than three hundred mourners, including California governor Pat Brown and Los Angeles mayor Tom Bradley.

No matter how much money Factor donated to charitable causes in the last half of his life, he was unable to make the public like him. In the mid-'60s, Factor gave an enormous donation to a needy charity, but the newspapers that covered the event wrote about Factor's association with Al Capone, the Chicago Outfit and how he'd cheated people out of their life savings and lied about his own kidnapping that sent five innocent men to prison for 125 years. Factor also fronted for the Chicago Outfit, which was getting an estimated $2 million a year from the skim from the Stardust Hotel and Casino in Las Vegas. John "Jake the Barber" Factor refused to recognize the damage he had inflicted on others during his lifetime, but it was all over now.

ROGER TOUHY

Victim of Lies, Corruption, and the Chicago Mob

Touhy admitted that he broke the law during Prohibition by making beer but added that it was the best beer in America. He said that he was a rich, but honest bootlegger. His only criminal record in Chicago was for a parking violation. He lived in Des Plaines, Illinois, and the people of that quiet suburban town wanted to elect him mayor at one time. Touhy was also inducted into the Elks Club, sponsored by a Des Plaines resident for more than thirty years. The lodge was located on Lee Street, and Touhy quickly had slot machines placed in the lodge for illegal gambling.

In 1933, Capone had corrupt law enforcement officers arrest Touhy for the kidnapping of William A. Hamm, the brewery heir, when, in fact, the kidnapping had been committed by the Barker brothers working with gangster Alvin Karpis. The FBI had substantial evidence that the Barker-Karpis gang had kidnapped Hamm but had Touhy and three others arrested, indicted and put on trial for the crime. J. Edgar Hoover and Special Agent Melvin Purvis were behind this stupid move. Touhy and his friends were beaten by the police and the FBI and spent three months in solitary confinement for nothing. The trial revealed they were not guilty on November 28, 1933.

While awaiting release after the Hamm trial, Touhy was arrested again on December 4, 1933, this time for the kidnapping of John "Jake the Barber" Factor. Touhy was framed by Al Capone, Thomas Courtney and Factor. Capone, Courtney and Factor had arranged to fake the kidnapping and produced the evidence implicating Touhy in order to get rid of him. Capone

Touhy and Company—innocent. *Courtesy of the CPD.*

would then assume control over his bootlegging operation in the northwest side of Cook County, Illinois.

Factor himself was a known mobster and on the run from British authorities who were trying to extradite him to England on mail fraud charges. Factor's plan was to have Touhy and a few of his associates arrested for his kidnapping. Factor would pay off a few of Touhy's associates to swear they were part of the crew that kidnapped Factor on June 30, 1933, on a Chicago street corner. The plan worked, and all of the witnesses perjured themselves in an attempt to convict Touhy and the others.

When one juror admitted he had perjured himself during the trial, it was declared a mistrial on February 2, 1934. A second trial began on February 13, 1934; Factor perjured himself again, as the other witnesses for the prosecution also repeated their lies. Touhy was screwed, and he knew it. He and his three associates were found guilty by the jury and sentenced to ninety-nine years in Stateville Correctional Center on February 22, 1934.

Touhy immediately filed an appeal, which he continued doing for the next 8 years, but the appeals were ignored. The answer always was the same: "Denied without a hearing." The year was 1942. Touhy was very discouraged; first and foremost, he was under a sentence of 99 years of

which he would have to serve a third, 33 years, before even being allowed to apply for parole. When they added 199 years to the 99 years because of his escape that totaled 298 years in prison—99 years before he could even apply for a parole.

Touhy then realized that he still had Morrie Green's proof of his innocence in the Factor frame. If he could get the evidence before a reasonable judge, he could expect to be rid of the 99 years. Then, in 1948, Touhy got his biggest break since entering prison. A Chicago lawyer, Robert Johnstone, heard about his case and came to see him. They talked together for four hours in the visitation room. Johnstone questioned and cross questioned Touhy trying to catch him in a contradiction or a lie. He couldn't, because Touhy was telling the truth.

Johnstone told Touhy that he believed him and that this was the worst case of injustice he had every heard of. Morris Green was an outstanding investigator and did a great job convincing Isaac Costner to tell the truth. Johnstone flew to Leavenworth Prison and interrogated Costner, who admitted that he had been persuaded to perjure himself at the second Factor kidnapping trial in 1934 by Jake the Barber and the chief investigator of the Cook County State's Attorneys Office, Daniel "Tubbo" Gilbert—in effect, the prosecution.

Albert "Obie" Frabotta, a killer with the Chicago Outfit, assisted in the murder of Roger Touhy. *Author's collection.*

Felix "Milwaukee Phil" Alderisio, killer of Roger Touhy. *Bob Wiedrich collection.*

Further investigation revealed that other witnesses against Touhy were paid off or threatened by Tubbo Gilbert or Factor, such as Buck Henrichsen, Ed Schwabauer and his mother, Mrs. Sczech. They all signed affidavits that they perjured themselves and swore there never was a kidnapping. Even though there were sworn affidavits that the witnesses lied, they were never criminally charged with perjury.

In the history of organized crime, no other figure had to endure the injustices that Roger Touhy faced, including his mob execution. Through numerous interviews with reliable informants, it has been learned that two known Outfit hit men used shotguns to kill Roger Touhy: Felix "Milwaukee Phil" Alderisio and Albert "Obie" Frabotta, both cold-blooded killers. I recall that Alderisio was arrested by the Chicago Police on May 2, 1962, on Superior Street in a 1962 Ford sedan, a hit car. His partner at the time was Chuck Nicoletti, another killer. The backseat opened up, and police found brackets for rifles, shotguns or handguns. There was a switch that flipped the license plates over and other gadgets that opened armrests for handguns, armor plating on all sides, bulletproof windows and a souped-up engine. That car could probably be a great addition for our military in Iraq right now.

ABOUT THE AUTHOR

 native of the Windy City, Don Herion joined the Chicago Police Department in 1955. On a cold winter night in 1959, he was called to the scene of Roger Touhy's murder. Herion retired after forty-eight years on the job, including two years of undercover work for the Chicago Crime Commission. He is the author of *Pay, Quit or Die* and *The Chicago Way*.

Visit us at
www.historypress.net
..
This title is also available as an e-book